M000106013

POSTCARD HISTORY SERIES

Williamsport's Millionaires' Row

The City of Williamsport, Pennsylvani

Located in the Centre of a Circle with a Radius of 170 Miles, Makes WILLIAMSPORT

Williamsport's

Advantages

as a

Manufacturing

Location

Are

Unexcelled

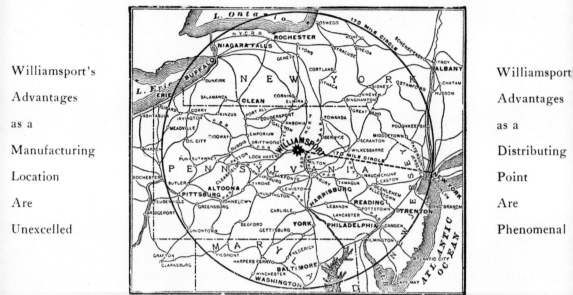

Williamsport

Advantages

as a

Distributing

Point

Are

Phenomenal

The Very Centre of Pennsylvania's Great Coal, Iron and Lum
ber Regions and of the Greatest Manufacturing
District in the World

This *c.* 1903 map portrays Williamsport as an industrial focal point after reigning as "Lumber Capital of the World" during the late Victorian era.

POSTCARD HISTORY SERIES

Williamsport's Millionaires' Row

Thad Stephen Meckley

ARCADIA
PUBLISHING

Copyright © 2005 by Thad Stephen Meckley
ISBN 978-0-7385-3797-9

Published by Arcadia Publishing
Charleston, South Carolina

Printed in the United States of America

Library of Congress Catalog Card Number: 2005920281

For all general information contact Arcadia Publishing at:
Telephone 843-853-2070
Fax 843-853-0044
E-mail sales@arcadiapublishing.com
For customer service and orders:
Toll-Free 1-888-313-2665

Visit us on the Internet at www.arcadiapublishing.com

This book is dedicated to the countless people who have shaped my mind in teaching me about history and have left me wonderful examples of Victorian architecture in Williamsport and around the country that I have had the pleasure to view, absorb, learn from, and care for. From all this, I have nurtured a love for the past, and through age-old lessons learned from history, I have developed a hope of great things to come for the future.

I dedicate this work to the people who have come to love, appreciate, and respect Williamsport as home—past, present, or future—staying true to the course of "a proud past and a promising future," as our city slogan reads.

I dedicate this book personally to my grandmother Ardice Owenson LaGrange Kolb—my mentor, sage in all things family, and inspiration in life. For it is from her that I have derived my love of history, my passion to preserve the past, my respect and appreciation of family heritage, and my place as a fifth-generation Williamsporter. No greater gift can be instilled in me than these things as well as her love and support.

CONTENTS

ACKNOWLEDGMENTS

Thanks to Peter DiBartolemeo, whose bountiful collection of Williamsport postcards was instrumental in adding to the story that I wished to tell and teach within these pages. Pete exemplifies a proud Williamsporter who likes to share his passion for all things Williamsport—namely postcards—with others.

And, along these lines, I would like to thank various others who embody this same spirit: Brian T. Carson, Daniel Bower, Philip Sprunger, Barbara and Walt Fullmer, Robert E. Kane Jr., Reuel Hartman, the Brooks Reese family, the Elizabeth Ackerman Estate and Roan family of Roan Auctioneers and Appraisals Inc., and Barbara Calaman of the Lamp Post Studio.

Thanks to Joanne Stetts-Maietta for the use of her extraordinary and extensive Williamsport collection, which helped to further this story that is told in so few images but that are truly worth a thousand words each. Visiting her beloved home—historic Hickory Hill, in Newberry—is truly a step back in time.

To all my lifelong friends of the L. L. Stearns family, thanks for sharing your family heritage memorabilia and for the shear enjoyment of knowing more about the special and legendary L. L. Stearns and Sons department store, which was "the place to shop" for countless generations, including myself. I am glad to have experienced the legend and hold those memories dear in my heart as I do your friendships.

To my friend the late Dr. Samuel J. Dornsife, I thank him for all of the knowledge that he taught me about Williamsport, its architecture, people, and proper period house paint colors. His countless tutoring lessons when he shared his time, thoughts, personal experiences, reference materials, photographs, and his special wit were priceless and invaluable to me, especially in writing this book. You are missed, but not forgotten.

I would like to thank Sandra Rife, executive director, Scott Sagar, curator, and Grace Callahan, gift shop store manager, of the Lycoming County Historical Society and Thomas Taber Museum, for their efforts both with this book and in their daily routine of managing, collecting, teaching and preserving the heritage of Williamsport and Lycoming County above and beyond that of the postcards used.

Technical support thanks go out to the amazing trio of Melinda Saldivia, of First Contact, and Bobbi Jo Shank and Matthew Klinepeter, of M² Computer Services.

A special thank-you goes to Erin Loftus, Brendan Cornwell, and the staff at Arcadia Publishing for all their guidance and expertise in making this book a reality.

Finally, I could not have completed this monumental project without the support and motivation of my friends and my family, especially my daughter Ella Victoria Meckley. Thanks, guys. I hope I did you all proud.

INTRODUCTION

Call it fate as you may, but this book was truly written in the cards for me—postcards, that is. While I had contacted Arcadia several years ago in the hopes of writing a book on local history, I put the idea on the back burner until fate came knocking at my door. It was in the form of a postcard (sent by my great-grandfather in 1932) that came to my front door two Christmases ago.

For a mere $1.95 on eBay, I unknowingly bought a postcard sent by my great-grandfather in 1932. This twist of fate fostered the thought of sharing this event and such cards with others. From that day forward, fate keeps sending me notes in the form of postcards to tell me that I am on the right path in writing this book.

Furthermore, when I happened to reconnect with a wonderful local family, the Carsons, who were mutual friends of my late friend Sam Dornsife, I found in their collection a postcard sent by my great-great-grandfather to other relatives of mine in nearby Nesbit, Pennsylvania.

What are the odds that twice now I have come across such postcards—messages from relatives long ago?

In addition, my daughter Ella is named after "Stella" mentioned on this newfound treasure. Estella Huber Kolb was my great-grandmother on my maternal side. While Estella and Stella were considerations, we decided upon the name Ella in April 2002. In this case, I think my great-grandmother is smiling proudly from above and not jealous in the least, as she might have been in 1910 (see page 8).

Putting this book together has been a true labor of love. The countless hours of interviews and meetings with new acquaintances have become wonderful memories. Thus, the flavor of the postcards chosen for this publication and the spirit of the collectors selected exemplifies why I wanted to write this book. It melds the history and architecture of Williamsport's Millionaires' Row with the family heritage and stories of so many, including my own. This book hopefully will evoke community pride and respect for the heritage of each reader's own family. Whether rich or poor, longtime resident, or passing glamorous society figure, all played their part in forming the town of Williamsport.

As for the history of postcards, I offer the following brief lesson for those not familiar with postcard evolution.

In Europe, postcards were available for sale in 1870 following the Post Office Act. In America they went on sale three years later. It was at the World's Fair in 1893, however, that postcards became popular. Picture postcards were available via vending machines, and thousands of technology-curious visitors purchased them. These were undivided-back postcards, which were popular up until 1898.

Great Britain followed suit by making picture postcards available in 1984. But it was Germany that seemed to lead the way for both ideas and quality in the printing of postcards. Likewise, the *gruss aus* (greetings from) cards from Germany are the forerunners to the popular America versions of souvenir postal greetings, some of which are featured in this book. This is the type of postcard that is familiar to all who have traveled to various beaches or summer resorts where such mementos are made available at the token two or three for $1 price.

At first, many people simply sent or exchanged cards with whomever they addressed them to. Then, in 1907, the practice of writing on the same side as the address became permitted in the United States during the divided-back era (1907–1915). Thus, today we have little clues as to the names of the senders of many such early cards.

The postcard-sending craze was said to continue up until the 1940s and 1950s, when it fell out of favor. Today, the Internet reigns supreme as the way to send news and quick hellos. Furthermore, the genre of sending postcards takes on the latest, less permanent state in the sending of electronic postcards.

While an e-mail postcard is nice to receive, I still prefer and enjoy the real thing. Hopefully, you too will rethink your interest and use of postcards, both those available to buy and those of long-ago relatives tucked away in your attic. Many involved in the writing of this book already have been touched with the "postcard bug," experiencing renewed appreciation of the collecting and sending of postcards. Happy hunting and enjoy!

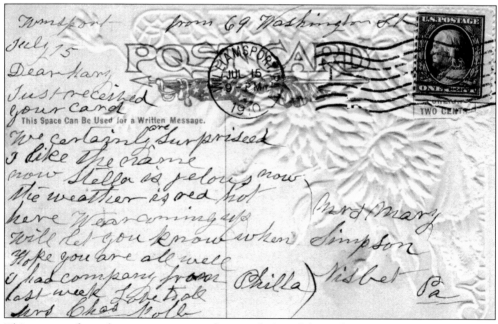

This message from the past comes to us from a relative of the author.

One

LOWER MILLIONAIRES' ROW

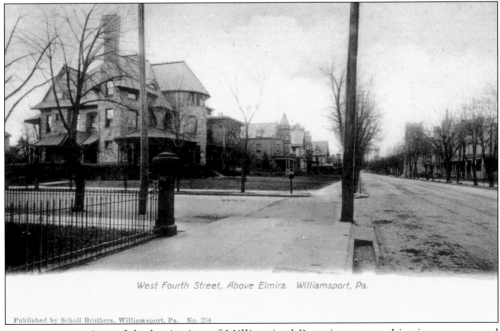

West Fourth Street, Above Elmira. Williamsport, Pa.

Published by Scholl Brothers, Williamsport, Pa. No. 254

A picturesque view of the beginning of Millionaires' Row is seen on this vintage postcard offering a unique glimpse into the days when the legendary Williamsporter Peter Herdic's dream evolved. (Sprunger collection.)

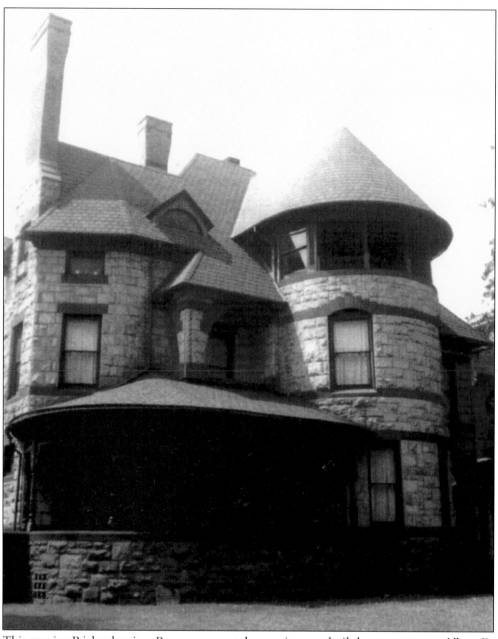

This massive Richardsonian, Romanesque-style mansion was built by entrepreneur Albert D. Hermance in 1885. He made his fortune and fame in Williamsport as co-owner and founder of the Rowley and Hermance Machine Company, which still operates in Williamsport today. The mansion, at 405 West Fourth Street, was restored to its original glory by its current owners. (Calaman collection.)

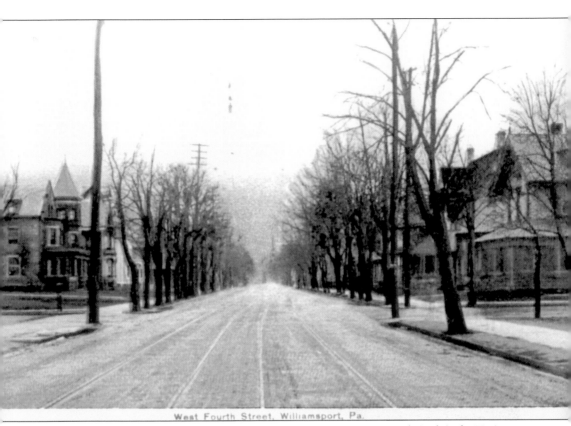

West Fourth Street, Williamsport, Pa.

This street scene of the start of Millionaires' Row includes 404 West Fourth (right), the Trainer-Burrell-Weaver residence. Furniture maker J. Hile Weaver remodeled it in the French Renaissance style, hiring famed Philadelphia architect Horace Trumbauer to do the job. It was home to the well-known local eatery, the Lucille Tea Room, before it was torn down to make way for the modern brick structure that stands there now. (T. S. Meckley collection.)

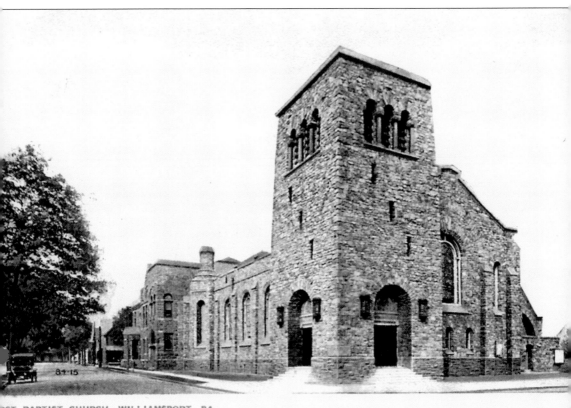

After the floods of 1889 and 1894 ravaged the original building, the First Baptist Church was rebuilt in 1898 on land donated by Peter Herdic, whose wife was a member. Herdic stipulated that the site must be a house of worship in perpetuity, or the land would revert to Herdic heirs. (Daniel Bower collection.)

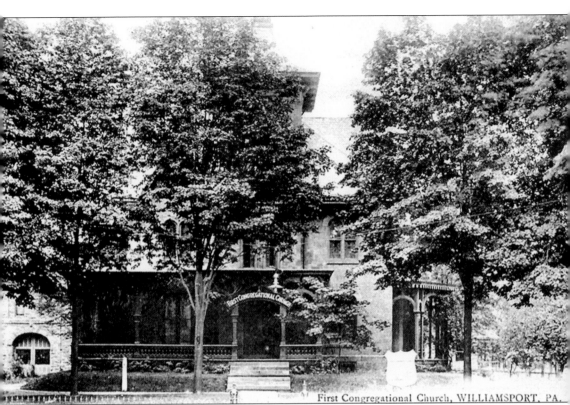

First Congregational Church, WILLIAMSPORT, PA.

After more than 20 years of worship at this location, the Congregationalists disbanded in 1919. Their house of worship, shown here, was built as the residence of Congressman William H. Armstrong, who helped write the Pennsylvania Constitution of 1872–1873. The Gothic-style mansion was designed by renowned U.S. architect Samuel Sloan, but sadly it was demolished to make way for the "new" YMCA facilities in 1922. (Daniel Bower collection.)

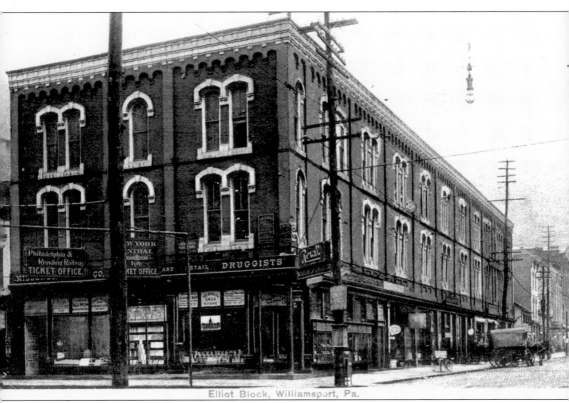

Elliot Block, Williamsport, Pa.

The Elliot Block was built by William G. Elliot, who purchased the Armstrong residence in 1872. Mayor of Williamsport from 1893 to 1897, Elliot created storerooms, offices, and lodge rooms along with his famous Elliot's Academy of Music on the second floor. National performers of the day entertained large crowds here. Elliot owned the National Paint Works, which manufactured asphalt and paint, selling mostly to the railroad and bridge-building industries. (T. S. Meckley collection.)

The YMCA addition (right rear) was added in place of the Metropolitan Block, a five-unit Victorian townhouse-style building, which was demolished. The facility—still a part of the YMCA complex today—was built in 1922 after various town fathers felt the need for a new YMCA home. (T. S. Meckley collection.)

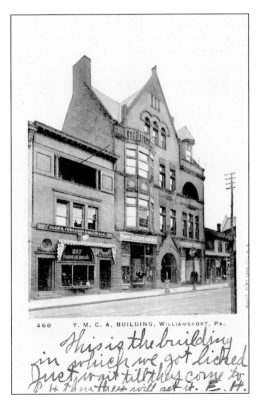

468 Y. M. C. A. BUILDING, WILLIAMSPORT, PA.

This is the building in which we got licked Just wait till they come to __ + then they will get it. E. H.

Prior to 1922, the YMCA's facilities were located in the impressive four-and-a-half-story Victorian office building at 211 West Fourth Street. (Daniel Bower collection.)

15

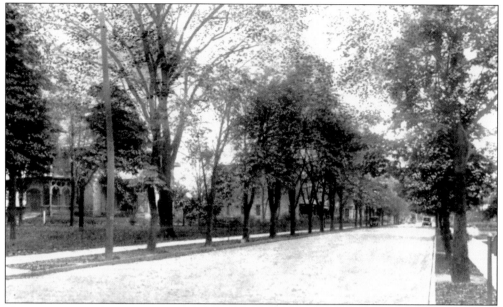

Shown is a view of the Victorian homes, including the William Elliott Mansion (left), looking from West Fourth Street down upon Elmira Street. The Elliot family lived there for more than 25 years. Behind it, a glimpse can be seen of the Metropolitan Block, the upscale Victorian townhouses designed by Williamsport architect Eber Culver. (T. S. Meckley collection.)

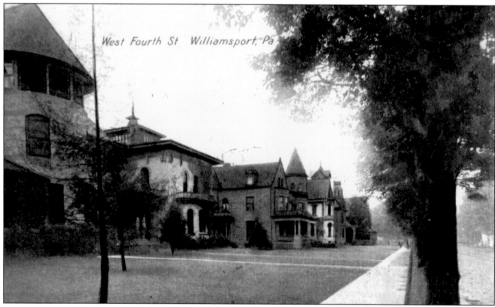

Peter Herdic's stately Italianate mansion was originally bedecked with cupola peaks from behind the towering turret of the Hermance Mansion. Lemuel Ulman's Queen Anne–style home and the richly decorated Gothic-style home of Frederick Hartsorn flank Herdic's on the left and right. All three stand there today, with only the latter displaying any changes. (T. S. Meckley collection.)

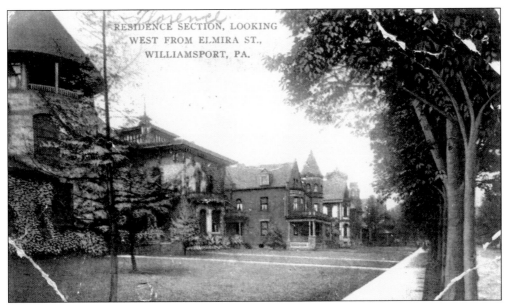

This residence section shows the homes of Williamsport's wealthy—Hermance, Herdic, Ulman, Hartsorn, and Dayton. The back of the postcard states, "The stores are all decorated lovely for Xmas. You ought to be here." (T. S. Meckley collection.)

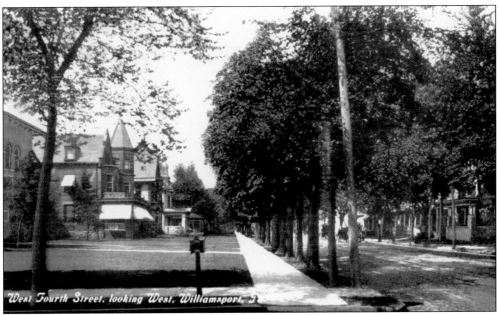

Awnings provide summer shade for the stately new home of clothier Lemuel Ulman, who worked at the family business, Moses Ulman's Sons (clothiers, tailors, and hatters), 39 and 41 West Third Street. Prior to being wed, Lemuel lived at 715 West Fourth, one of the few double houses built on Millionaires' Row. (T. S. Meckley collection.)

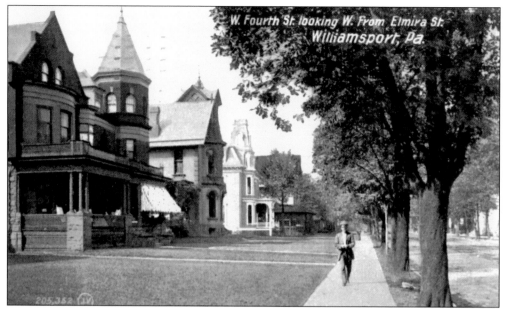

Here is a closer look at the Ulman home, which is now the Peter Herdic Inn Bed and Breakfast. Ulman built the regal Queen Anne–style building for his family in 1880, with Eber Culver as the designer. (T. S. Meckley collection.)

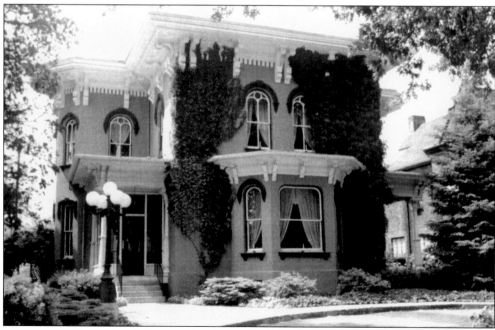

Winner of the Pennsylvania Preservation Award for 1983, the Peter Herdic House, now an elegant fine-dining restaurant, was originally the home for Williamsport's premier lumber baron. Built in 1855, the Italianate mansion stands proud at the foot of the Millionaires' Row that its builder created as well. (Calaman collection.)

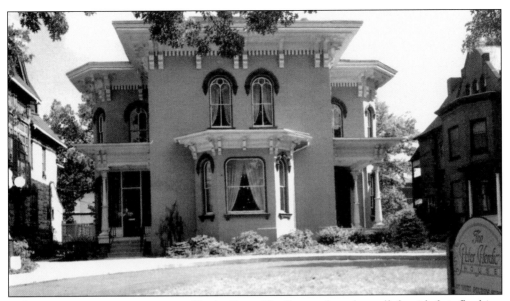

In later years, entrepreneur extraordinaire Peter Herdic was forced to sell the side lots flanking his home (407 West Fourth Street), where the two fine Victorians still survive today in all their finery. (T. S. Meckley collection.)

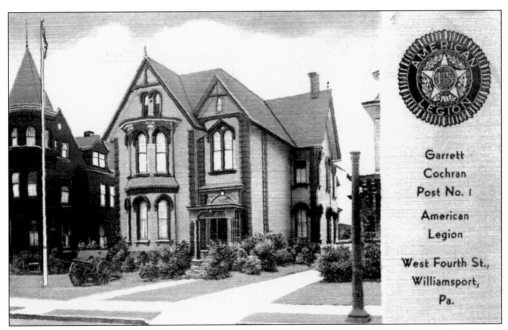

In later years, the Frederick Hartsorn home was host to the local American Legion before being altered by the 20th-century-style front addition. Portions of the Ulman house (left) and John B. Dayton house (right) are visible on either side. (DiBartolomeo collection.)

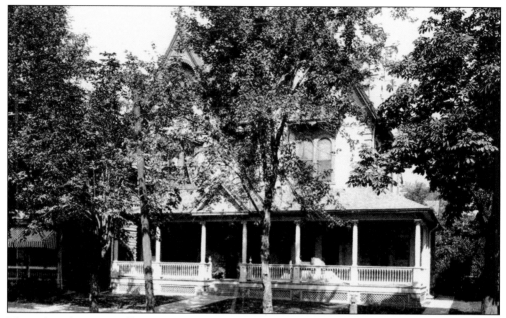

The Edward A. Cornell House (420 West Fourth Street) sports its original beauty here with its stucco facade adorned with corner quoins, decorative gingerbread trim, and its "second-generation" porch. (Private collection.)

Fledgling L. L. Stearns department store executive Charles R. Stearns lived at 424 West Fourth Street at one time. Note the Victorian store trade card, which is a favorite addition to local postcard collections. (L. L. Stearns family collection.)

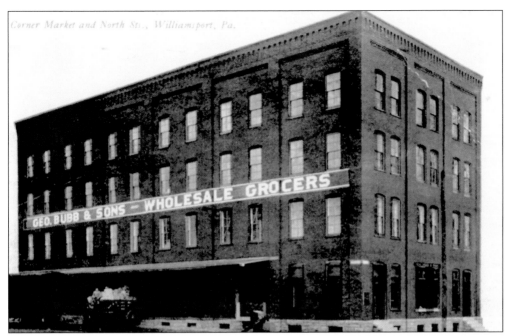

Harry C. Bubb worked for his family business of George Bubb and Sons, which is shown at its 460 Market Street location, now known as the Williamsport Building. Harry Bubb was involved with the lumber interest of N. B. Bubb and Company, at 108 West Fourth Street. He and brother Nathaniel B. Bubb had an interest also in the steam cracker bakery of Fisher, Hinkel and Company along with Edward J. Fisher and Daniel M. Hinkel, 253–261 West Third Street. (T. S. Meckley collection.)

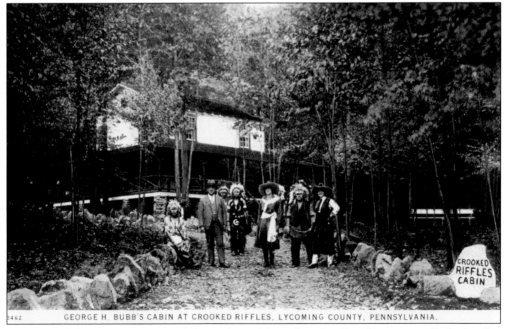

GEORGE H. BUBB'S CABIN AT CROOKED RIFFLES, LYCOMING COUNTY, PENNSYLVANIA.

This out-of-the-ordinary postcard shows the Bubbs at their family cabin retreat, displaying fun times and the spoils of their family fortune. (T. S. Meckley collection.)

21

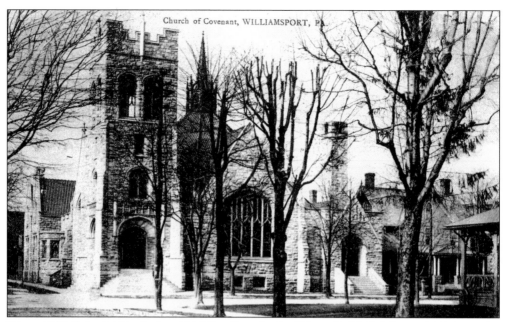

The *c.* 1910 Colonial Revival at 424 West Fourth, the Hiram B. Melick house (right), can be seen next to the 1893 Church of the Covenant. Later, this limestone edifice was home to the St. Paul's Lutheran congregation, which moved to another building when the church closed. One of its Tiffany stained-glass windows is now on display at the Thomas Taber Museum just down the street. A hint of the Wolf-England-Sanderson-Bubb house porch (right) can be seen as well. (T. S. Meckley collection.)

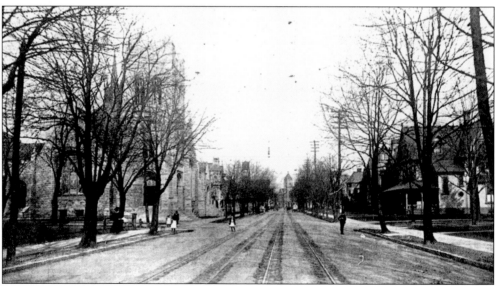

Williamsport youths frolic on West Fourth Street. The writer of the postcard tells a Lock Haven friend that "this is on my street and a fine one it is." The Harry C. Bubb house (now demolished), at 435 West Fourth Street, can be seen on the southeast corner of Locust and Fourth Streets. (T. S. Meckley collection.)

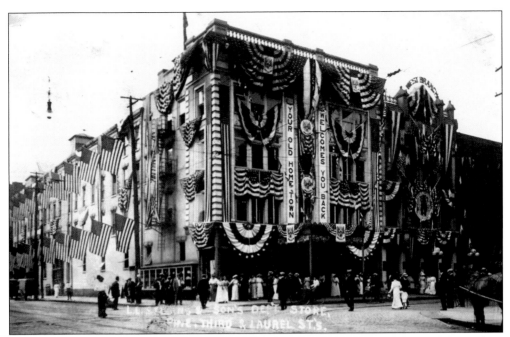

Family business president George L. Stearns and his family celebrated many a holiday at their Millionaires' Row homestead at 511 West Fourth Street. Pictured is a real picture postcard of their business in full celebratory regalia, having enlarged in 1909, when it absorbed the bank building next door. (L. L. Stearns family collection.)

Sons J. Augustus, Charles R., and George L., who were admitted into the business in 1883, pose with father Laten Legg Stearns in front of their new store in 1865, shortly after moving to Williamsport from Jersey Shore, Pennsylvania. Their first downtown location was on Market Square until 1889, when they moved to the former City Hotel, corners of Pine, West Third, and Laurel Streets. (L. L. Stearns family collection.)

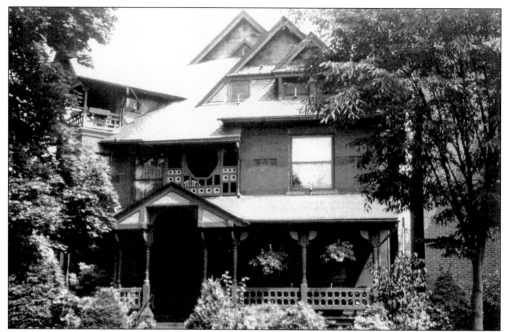

This magnificent Eastlake Queen Anne–style Victorian was built for the Hiram Rhoads family in 1888. Eminent architect Eber Culver crafted the mansion (522 West Fourth Street), which features bejeweled windows, cherry, pecan and mahogany woodwork, and bronze gilded door hardware. In 1878, with 25 eager (and wealthy) subscribers, he brought the second telephone exchange in the state to Williamsport; Erie was the first. Rhoades came to town with his parents in 1859 from Philadelphia. He made his fortune in the telephone, electric, and transportation industries but died at an early age (48) in 1894. (Above, Calaman collection; below, T. S. Meckley collection.)

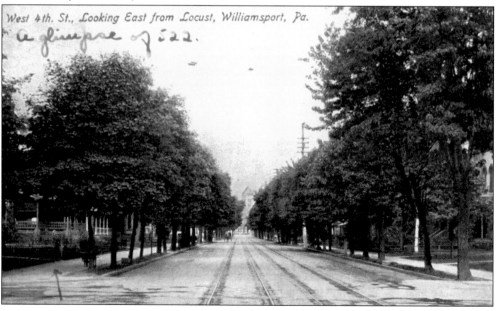

West 4th. St., Looking East from Locust, Williamsport, Pa.
a glimpse of 522.

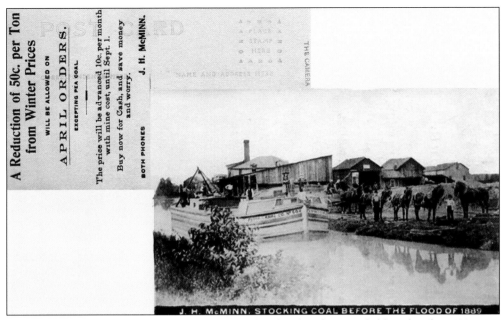

A Reduction of 50c. per Ton from Winter Prices

WILL BE ALLOWED ON

APRIL ORDERS.

EXCEPTING PEA COAL.

The price will be advanced 10c. per month with mine cost, until Sept. 1.

Buy now for Cash, and save money and worry.

J. H. McMINN.

BOTH PHONES

POSTCARD

PLACE STAMP HERE

THE CAMERA

NAME AND ADDRESS HERE

J. H. McMINN, STOCKING COAL BEFORE THE FLOOD OF 1889

Coal and lumber magnate J. H. McMinn and his family of seven children lived at 528 West Fourth Street for just over 20 years. This modest *c.* 1850 home was later remodeled into the magnificent neo-Colonial residence of Francis Bowman, son of Benjamin Bowman, who bought the home in 1871 for $12,000. It was destroyed by fire in the late 1990s. McMinn's coal business is advertised on the *c.* 1889 postcard above. (Above, Taber Museum collection; below, Kane collection.)

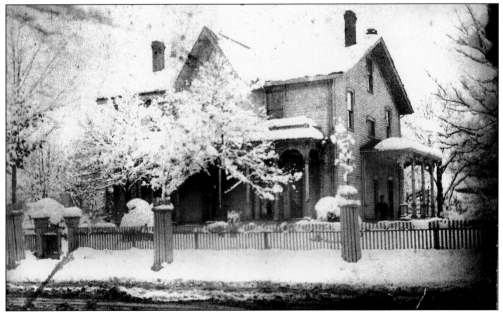

25

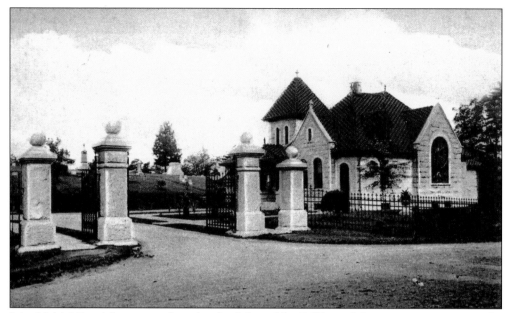

John H. McMinn is best remembered as the father of the Wildwood Cemetery. McMinn was the one who drew up the plans for this incredible Victorian-style sanctuary. In 1863, Peter Herdic, George White, Robert Faries, and Judge Armstrong purchased the wild, wooded plot of land that would become the Wildwood Cemetery. McMinn and the other founders were laid to rest there. (T. S. Meckley collection.)

Lumberman William V. Emery was a jack-of-all-trades, working as a mercantile grocer in his earlier career, as noted by this rare trade card. Emery spent part of his fortune on the modest Queen Anne–style residence, located at 535 West Fourth Street. The *c.* 1888 Millionaires' Row home was designed by architect Eber Culver. (T. S. Meckley collection.)

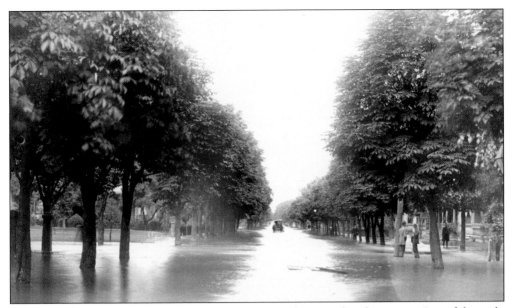

This recently discovered glimpse is the only known photographic documentation of the early Victorian structures on the 600 block of West Fourth Street. In his book *Lost Williamsport*, historian Samuel Dornsife made note of this elusive missing link, which was found during the research for this book. (Private collection.)

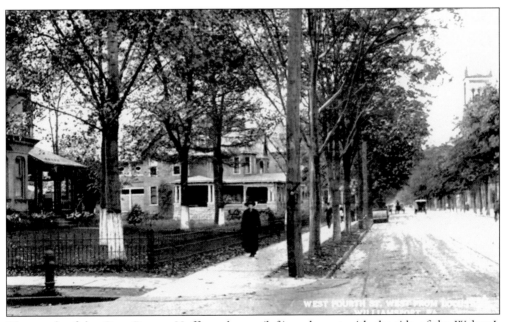

The porch of the Otto-Brown-Hoffman house (left) peeks out with the side of the Walter J. Walton Bowman house, 619 West Fourth Street, next door. Bowman had the first automobile in Williamsport. The wealthy lumber baron is best remembered, however, as the chief supporter of professional baseball in Williamsport. Bowman Field was named in his honor. The field is the second oldest minor-league field in the country. (T. S. Meckley collection.)

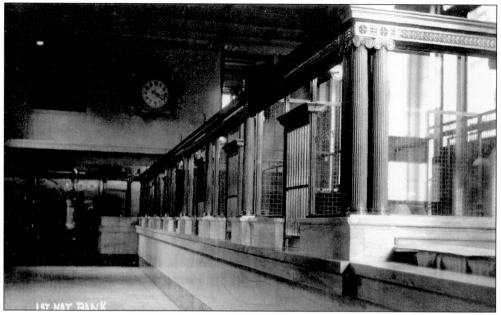

Here is a rare look at the interior of the First National Bank (25 West Third Street), later the former Fidelity National Bank site. Lawyer J. Artley Beeber, who lived at 600 West Fourth Street, was bank president in 1906. Beeber also served as the president of the Ross Club when it was founded in 1891. (DiBartolomeo collection.)

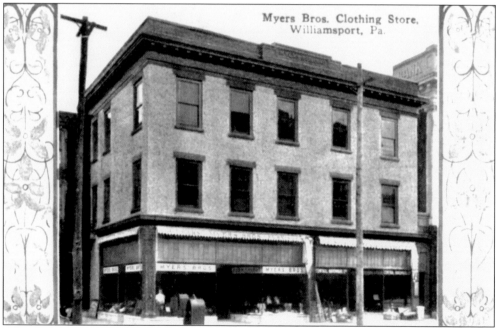

Leander I. Meyer built his stately brick home at 610 West Fourth Street in the early 1900s. The clothing manufacturer, who specialized in pants, was the owner of a downtown business called Meyer Brothers Clothing Store. Located at 674 East Third Street, Meyer built the store as well. (Stetts–Maietta collection.)

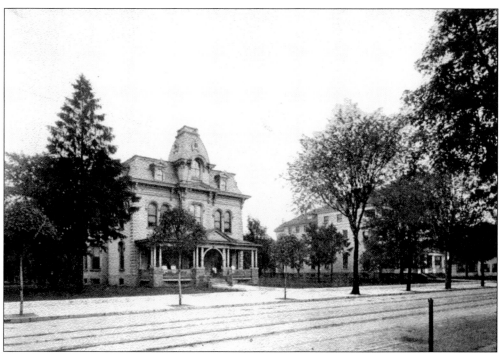

A look east catches the sights of Henry B. Smith's Second Empire Italian Villa–style homestead and the Ida Hays McCormick Mansion, formerly the Loren Kinyon Italianate-style home (right). The Smith residence, later home to the Moses Ulman family, was designed by well-known Philadelphia architect Isaac Hobbs and is the largest mansard in the Millionaires' Row National Historic District. (Above, private collection; below, Calaman collection.)

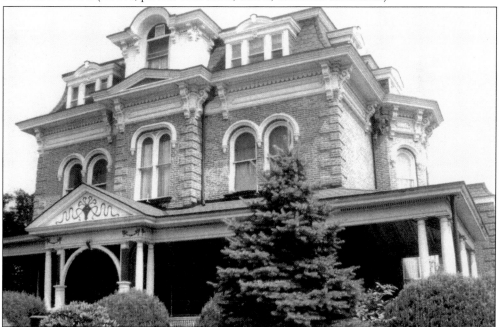

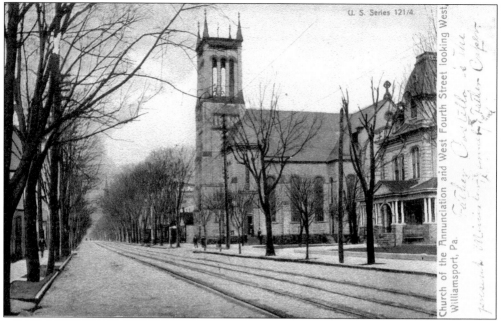

U. S. Series 121/4

Church of the Annunciation and West Fourth Street looking West, Williamsport, Pa.

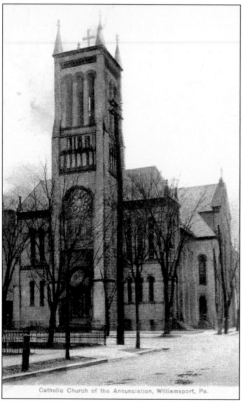

Catholic Church of the Annunciation, Williamsport, Pa.

The Smith-Ulman Mansion and the Church of the Annunciation are part of the Catholic Diocese of Scranton, Pennsylvania. On September 1, 1887, scaffolding used in building the church tower's spire collapsed, killing four of the six men who were working on the building. At that point, construction was halted. The four crosses that adorn the bell tower today commemorate the men's deaths. (T. S. Meckley collection.)

The E. A. Rowley house is considered by many to be the finest Queen Anne–style Victorian in Pennsylvania. Architect Eber Culver thought it was one of his best works. Built in 1888, the striking brick Rowley-Rishel Mansion (707 West Fourth Street) is an architectural jewel from the Victorian period. Its many original trappings reveal the wealth, tastes, and living habits of its former owners. Culver designed banker and lumberman Elias Deemer's late-1880s mansion (711 West Fourth Street), partially visible here on the right. (Calaman collection.)

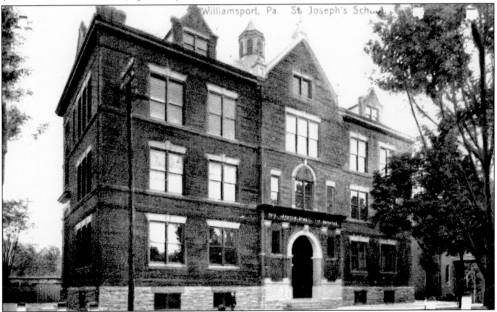

An active surviving member of Williamsport's historic district, St. Joseph's Parochial School offers education from kindergarten to sixth grade. In 1906, it had 525 scholars in nine classes. Recently, its bell tower was uncovered—along with its original bell—and restored. St. Joseph's is operated under the auspices of the Annunciation Church. (T. S. Meckley collection.)

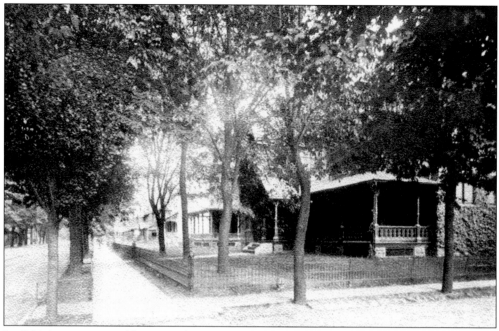

In 1888, law partners Addison Candor and Cyrus LaRue Munson built their homes side-by-side as the notable brick Victorians at 741 and 747 West Fourth Street, respectively. On top of being a senior law partner in 1906, Munson was president of the Savings Institution of the City of Williamsport, the E. Keeler Company, and the Williamsport Iron and Nail Company as well as secretary of the Williamsport Wire Rope Company. (Private collection.)

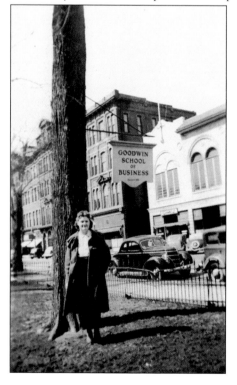

In later years, the Munson Mansion was home to the Goodwin Business School. Note the ornate commercial building in the background, which replaced the former Linck Block building that was destroyed by fire. (Stetts-Maietta collection.)

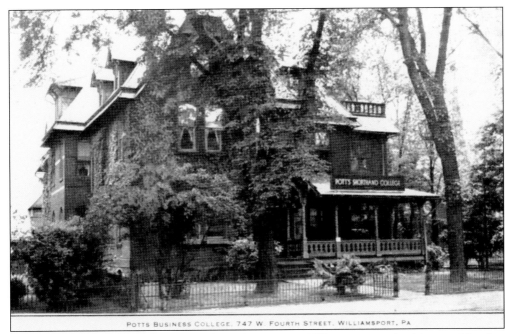

POTTS BUSINESS COLLEGE, 747 W. FOURTH STREET, WILLIAMSPORT, PA

The Pott's Business School relocated from downtown Williamsport to the Munson Mansion (747 West Fourth Street), operating there for a number of years. Today, the mansion is divided into rental units. (T. S. Meckley collection.)

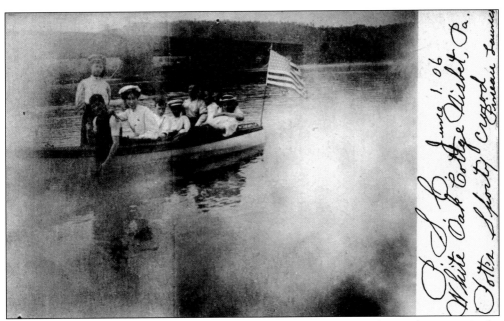

Students of the Pott's Business School enjoy the afternoon off at their White Oak Cottage in the village of nearby Nisbet along the Susquehanna River. The picturesque, real picture postcard names each student: Gus Pineau, Elmira Showers, Lawrence Tinsman, Mary Dreher, G. J. Griffin, Ida Dalton, Matthew Crowe, Helen Tobin, H. F. McCracken, and Mattie Bickel, as seen near Pineau Island. (Taber Museum collection.)

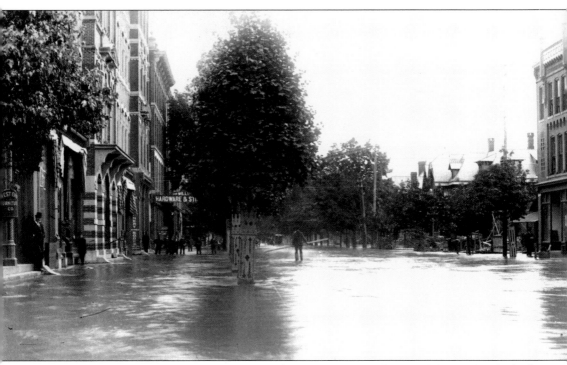

The Weightman Block (754–770 West Fourth Street) was originally named the Herdic Block after developer and builder Peter Herdic. This was to be the new center of business in Williamsport, but his bankruptcy in 1878 stopped Herdic from completing his vision. His holdings, including the unfinished commercial block, were bought by the "Quinine King" William Weightman, of Philadelphia. Weightman hired Eber Culver to complete the U-shaped edifice, which had concrete floors, 16-inch-thick plaster walls, 18-foot ceilings, and a different exterior window lintel on each of the three stories. The water seen in the postcard is from the flood of June 1889. (Stetts–Maietta collection.)

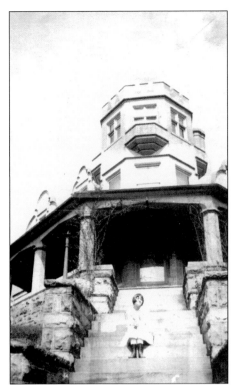

Dorothy Spangle, granddaughter of lumberman Brooks Reese, sits on the steps of the now demolished J. H. Linck Mansion. Linck operated his hardware-stove-coal business from his former building, the Linck Block (761 West Fourth Street), which was destroyed by fire. The business sat to the right of the Herdic-Weightman Block. (Right, Brooks Reese family collection; below, T. S. Meckley collection.)

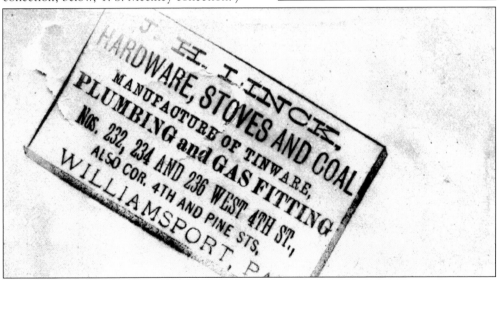

J. H. LINCK.
HARDWARE, STOVES AND COAL,
MANUFACTURE OF TINWARE,
PLUMBING and GAS FITTING
Nos. 232, 234 AND 236 WEST 4TH ST.,
ALSO COR. 4TH AND PINE STS,
WILLIAMSPORT, PA.

Built in 1871, the Herdic Block, also known as the Weightman Block, was to include an opera house, a public market, government offices, and courtrooms for the U.S. Western District of Pennsylvania, but Herdic never got that far. Herdic did persuade the Lumberman's National Bank, the Lycoming Gas and Water Company, and the Williamsport Manufacturing Company to rent there—he just happened to be the president of all of these businesses. (Ackerman Estate collection.)

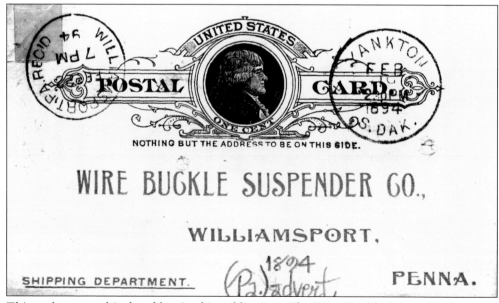

This trade postcard is the oldest in this publication. The Wire Buckle Suspender Company had its manufacturing operations located in the Weightman Block along Campbell Street. (DiBartolomeo collection.)

Two
HERDIC HOUSE HOTEL

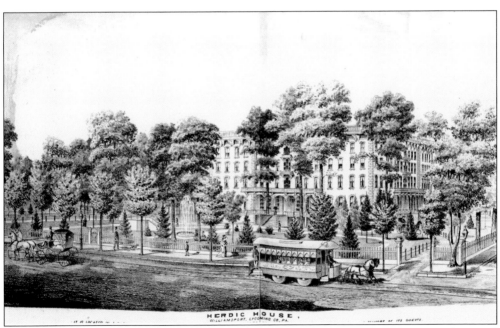

Built in 1864 by the legendary Peter Herdic, the Herdic House was intended to be the social gathering place of Williamsport's elite and those who traveled through the bustling lumber mecca. Herdic ordered his crew to "spare no cost or labor" in its construction. The Herdic House opened on September 25, 1865, which was coincidentally the same day that Herdic's new horse-drawn streetcar line opened in the city. Passengers shown could be transported to and from downtown Williamsport. (Taber Museum collection.)

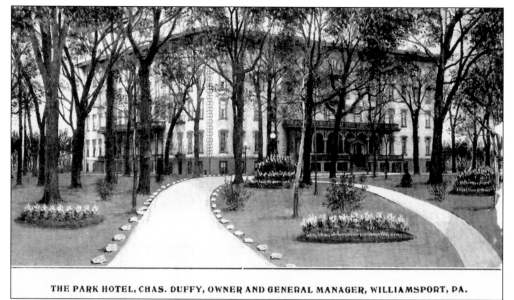

THE PARK HOTEL, CHAS. DUFFY, OWNER AND GENERAL MANAGER, WILLIAMSPORT, PA.

The Herdic House, renamed the Park Hotel in 1889 by Col. Charles Duffy when he took over, offered floral-lined, winding drives adjacent to parklike strips where guests could wander. In 1872, the hotel hosted 27,593 guests with a staff of 75, under the supervision of superintendent J. B. Winters. Colonel Duffy rented the hotel from wealthy Philadelphia socialite Annie Weightman Walker Penfield, who inherited it from her father, William Weightman, the "Quinine King" of Philadelphia. (Daniel Bower collection.)

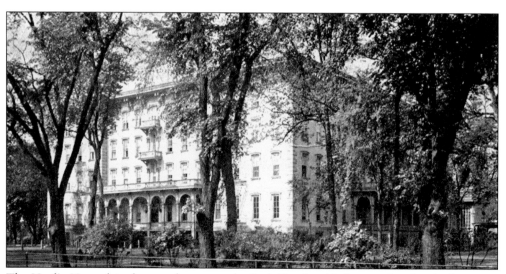

The Herdic House later became known as the Park Hotel, with four stories plus the basement on the ground level. In all, there were 175 sleeping rooms with bathrooms on every floor. (T. S. Meckley collection.)

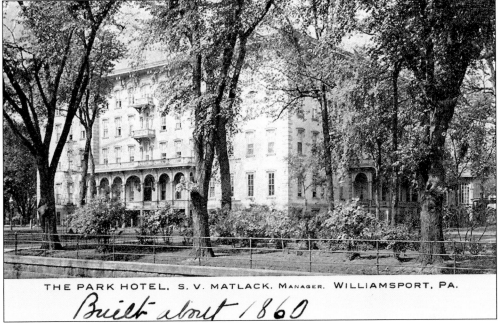

THE PARK HOTEL. S. V. MATLACK. MANAGER. WILLIAMSPORT, PA.

Built about 1860

The Park Hotel sat in an enclosed five acres, filled with native oaks and evergreens, tame deer and birds, enchanting fountains and lush flowers. The "Matlack" card writer dated the hotel to 1860, but it was completed in 1865. (Daniel Bower collection.)

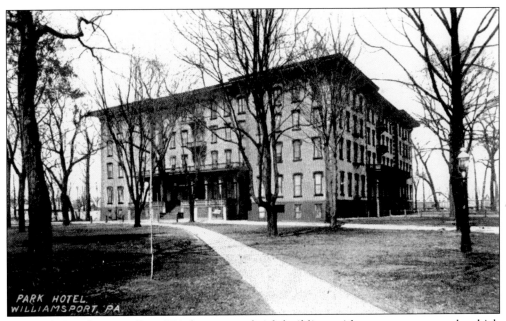

PARK HOTEL.
WILLIAMSPORT, PA.

The Park Hotel is actually a 156-foot square brick building with a center courtyard, which was open at one time. It cost Peter Herdic approximately $225,000 to build, with Eber Culver serving as his architect. Although rendered here in black and white, the original postcard shows the hotel with mustard-yellow walls and brown trim. The original color scheme has yet to be discovered. (T. S. Meckley collection.)

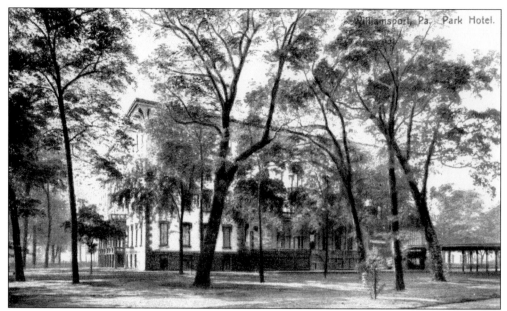

Illuminated with electricity and heated by steam, both operations were owned and operated by Herdic. The magnificent hotel provided accommodations for 700 guests. Other amenities included a ballroom, bar and billiard rooms, a barbershop, a cigar shop, a private theater, a news stand, numerous public parlors, gentlemen's and ladies' reading rooms, reception rooms, a fine dining restaurant, and a telegraph office. (T. S. Meckley collection.)

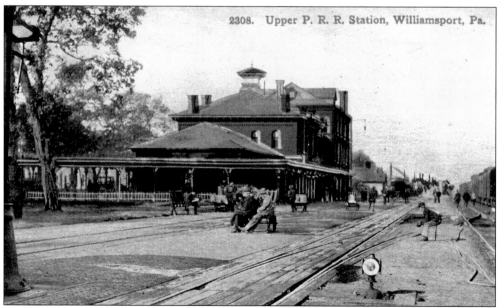

Herdic used his influence to convince the Pennsylvania Railroad to put its main depot next to his hotel, which faced the station and had a wide covered colonnade to and from the trains. (Fullmer collection.)

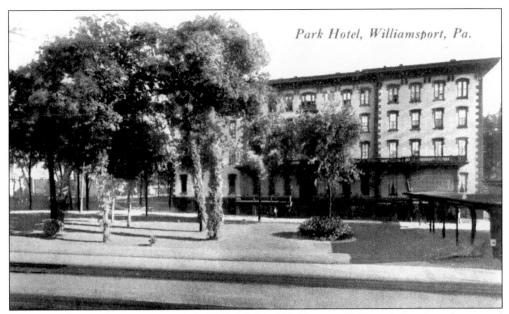

Park Hotel, Williamsport, Pa.

Passengers from Baltimore, New York, Philadelphia, Washington, D.C., and elsewhere frequented the hotel for overnight stays. Rates at the hotel were quite reasonable, not exceeding $3 per day. (T. S. Meckley collection.)

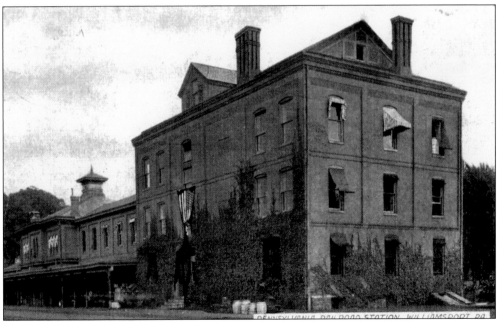

The Pennsylvania Railroad station at the Park Hotel is depicted here in all its glory. Today, only a small fraction of the enormous and bustling station remains. The remaining portion is being renovated as part of the Peter Herdic Transportation Museum, developed through the support of the Pennsylvania Historical Museum Commission. (T. S. Meckley collection.)

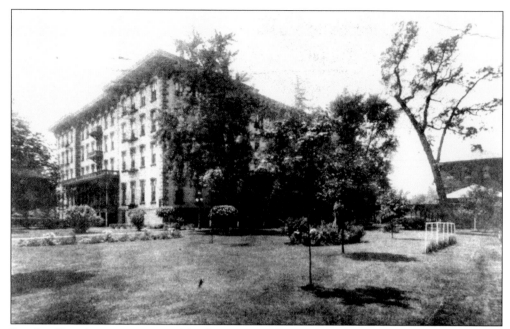

Rendered here is an austere view of the elegant Park Hotel (also known as the Herdic House) in 1908. Grand crystal chandeliers lit the tasteful and elegantly furnished lobby, while the hotel structure boasted marble tiled floors in its halls. (Above, T. S. Meckley collection; below, Carson collection.)

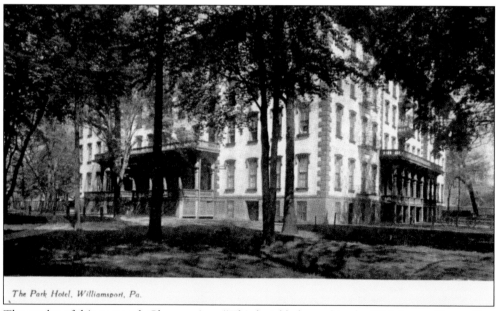

The Park Hotel, Williamsport, Pa.

The sender of this postcard, Clara, writes, "This hotel belonged to the Weightman Estate. You have no doubt read of the rich Mrs. Walker at Philadelphia. She was married just lately to a man in New York (U.S. Ambassador to the Court of Austria Frederick Courtland Penfield). She used to live here. Her name was Weightman before her first marriage (to lawyer and Congressman R. J. C. Walker). The hotel was first owned by Peter Herdic and was called the Herdic House." (T. S. Meckley collection.)

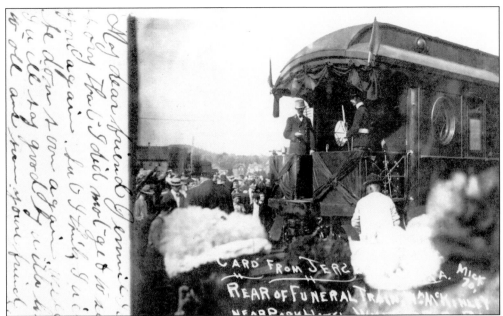

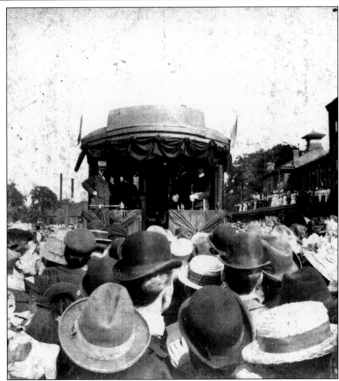

Onlookers view the funeral train of Pres. William B. McKinley at the Park Hotel's Pennsylvania Railroad station as it passes through Williamsport on September 16, 1901. This real picture postcard provides a rare glimpse of this historic visit. (Stetts-Maietta collection.)

Park Hotel and
Penna Station,
Williamsport, Pa.

These four postcards illustrate different views of the Pennsylvania Railroad station. Once the Peter Herdic Transportation Museum is completed, Trinity Place will once again serve as the entryway to activities at the station. Note the railroad offices to the side of Trinity Place. Only one of the offices remains there today in excellent exterior condition. (Above, Fullmer collection; below, T. S. Mickley collection.)

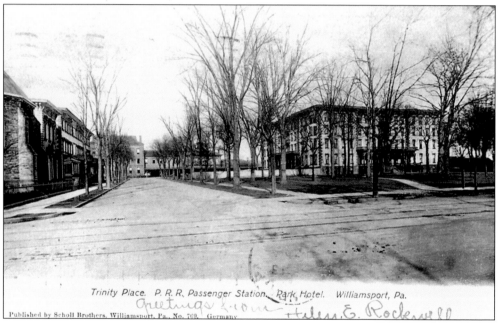

Trinity Place. P. R. R. Passenger Station. Park Hotel. Williamsport, Pa.

Published by Scholl Brothers, Williamsport, Pa., No. 769. Germany

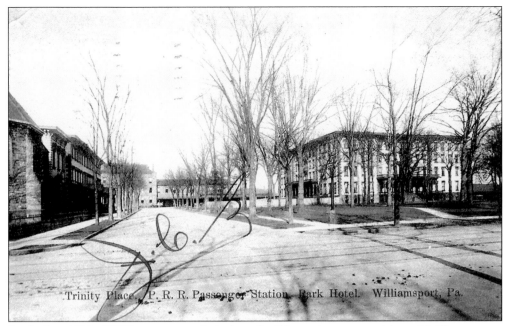

Trinity Place. P. R. R. Passenger Station. Park Hotel. Williamsport, Pa.

By the late 1880s, Williamsport was linked to all of the major eastern cities, with 20 passenger trains from five railroad lines making daily stops here at its two stations. (Above, Daniel Bower collection; below, T. S. Meckley collection.)

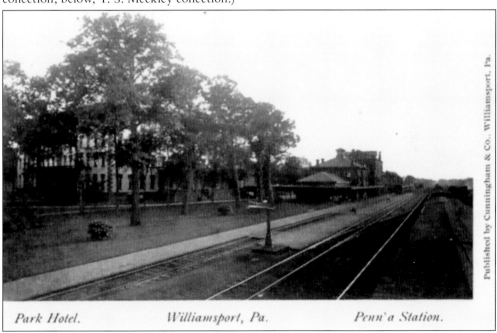

Park Hotel. Williamsport, Pa. Penn'a Station.

Published by Cunningham & Co. Williamsport, Pa.

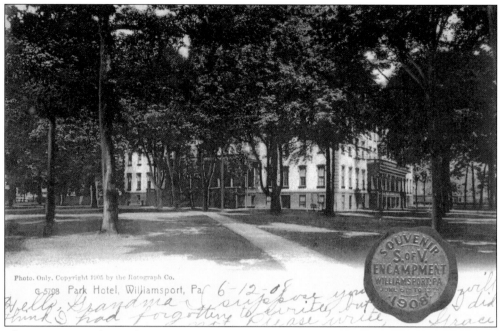

Photo. Only, Copyright 1905 by the Rotograph Co.

G-5798 Park Hotel, Williamsport, Pa

This rare 1908 Park Hotel postcard commemorates the historic encampment that was held here from June 6 to 13. (T. S. Meckley collection.)

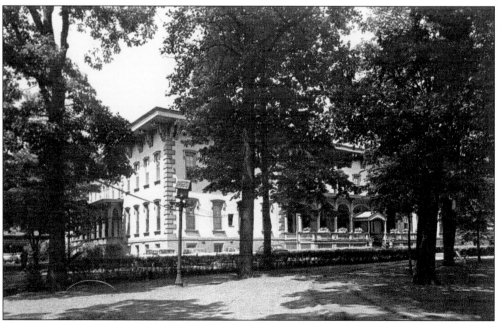

Local businessman William Bud Stuart purchased the grand hotel in 1930 and created an elegant retirement retreat for many aged ladies until the outfit moved its operations in the 1990s. Stuart removed the building's top two floors in 1940 to meet fire regulations of the day. (T. S. Meckley collection.)

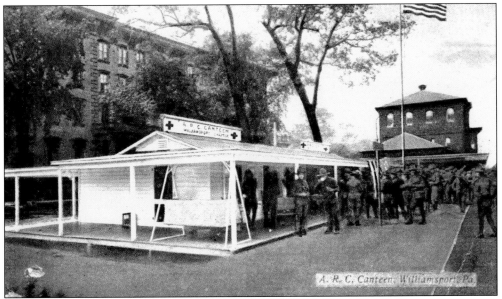

World War I soldiers enjoy the hospitality and care of the Williamsport Red Cross Canteen. The reverse side of the postcard tells the following solemn tale: "Always keep these cards as they cannot be procured again: World War I Soldiers at the Canteen on the lawn along the P. R. R. tracks at the Park Hotel station. I visited there many times. I shall never forget the trainload of shell-shocked soldiers passing thru there. Also, the wounded a deplorable sight." (Taber Museum collection.)

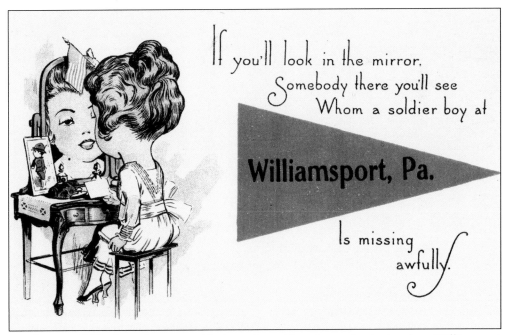

Another World War I novelty postcard is shown here. Note the vanity depicted—a Williamsport furniture (Rishel, Mankey, or Luppert) piece perhaps? (Stetts-Maietta collection.)

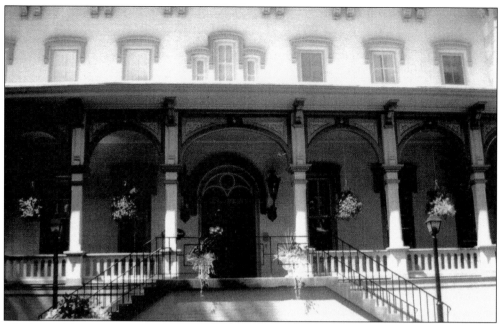

This beautiful postcard by Barbara Calaman provides a picturesque view of the recently renovated and restored Herdic House (now the Park Place building). Today, Park Place serves as a thriving office complex, not only for its current owners (Anthony Visco, Bill Brown, and Allen Ertel) but also for its other numerous business occupants. (Calaman collection.)

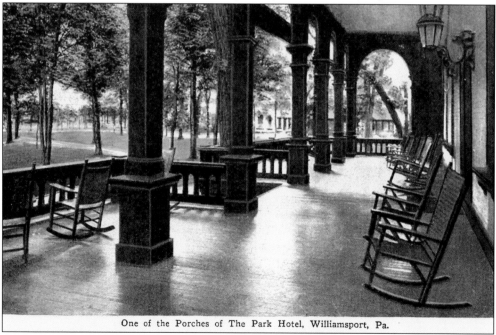

One of the Porches of The Park Hotel, Williamsport, Pa.

This unique card provides a step back in time to more gentle times when visitors to the Park Hotel took respite on the "rear porch," which faces West Fourth Street and is regarded as the front by many. The hotel was a favorite along the Susquehanna Trail, which brought travelers here via scenic Routes 15 North and South. (T. S. Meckley collection.)

Three
UPPER MILLIONAIRES' ROW

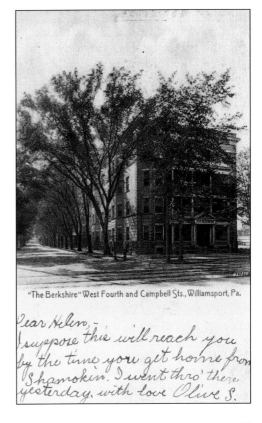

"The Berkshire" West Fourth and Campbell Sts., Williamsport, Pa.

Dear Helen,—
I suppose this will reach you
by the time you get home from
Shamokin. I went thro' there
yesterday. with love Olive S.

This unique card features a view of the Berkshire apartments and shows hints of the building's former neighbors, of which only one remains. The Berkshire was built around 1901 and was home to many prominent citizens, who lived in this new, citylike apartment dwelling. (T. S. Meckley collection.)

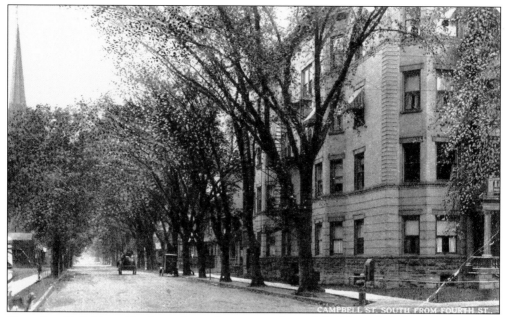

Note the old-fashioned barber pole to the extreme lower left. The pole belonged to business neighbor W. C. Bornman, the barber whose shop was located at 761 West Fourth Street. (T. S. Meckley collection.)

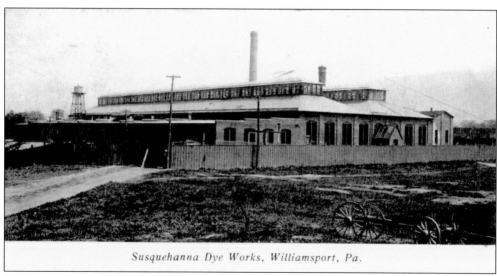

Susquehanna Dye Works, Williamsport, Pa.

One of the area's offshoot industry start-ups, the Susquehanna Dye Works was located at 1300 East Jefferson Street in East End Williamsport. This card bears a sweet birthday note from Sarah L. Stearns (widow of J. Augustus Stearns) to their son Thomas L. Stearns, who was attending the Cheltenham Academy in Ogontz, Pennsylvania. (Fullmer collection.)

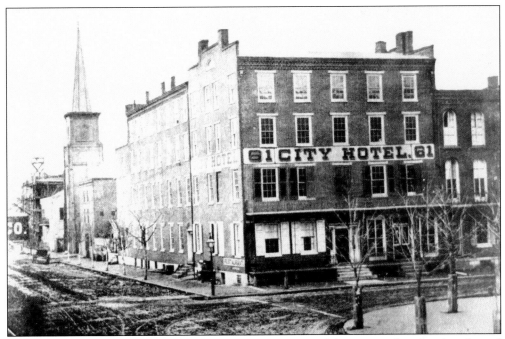

The L. L. Stearns store moved in 1889 to the former City Hotel, having purchased and performed renovations on it the year prior. (L. L. Stearns family collection.)

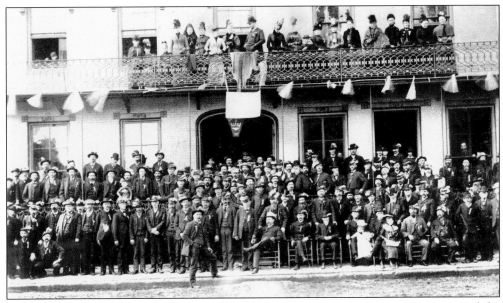

A group poses at the City Hotel on May 30, 1882, before the L. L. Stearns store occupied the building. (L. L. Stearns family collection.)

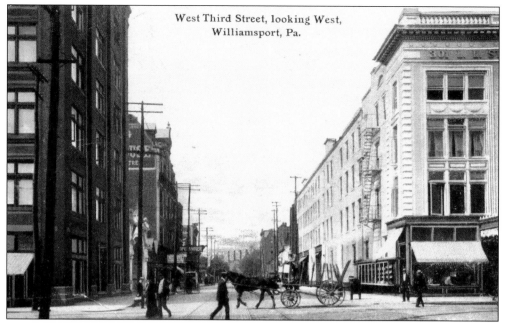

West Third Street, looking West,
Williamsport, Pa.

The L. L. Stearns store is shown here during its heyday. The postcard displays the illustrious A. H. Heilman and Company furniture store (left), which later became the Carrol House department store. (T. S. Meckley collection.)

A MERRY CHRISTMAS.
L. L. STERNS and SONS,
No. 1 West Third Street,
WILLIAMSPORT, Pa.

Here is an early trade card, on loan from the Stearns family scrapbook, which illustrates early advertising for the legendary Williamsport establishment. (L. L. Stearns family collection.)

Grace United Methodist Church, portrayed here, was built in 1885. The parsonage, shown next door, was built in 1886 and is owned by the author. The original land for the parsonage was given by Peter Herdic. It is where the original church, Price's Chapel, sat until it was dismantled. In 1906, the church had 400 members and 326 scholars as well as 1,000 volumes in its library. (Victorian Ventures collection.)

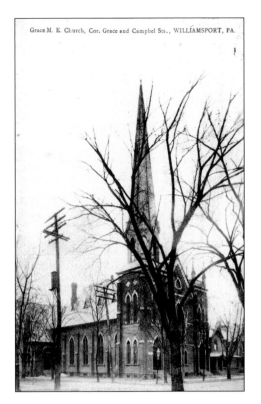

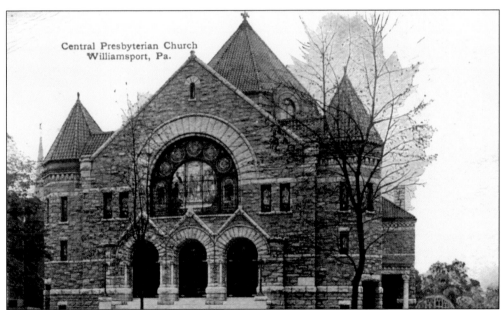

Built in 1906, Covenant Central Church replaced the former J. C. Dodge residence, built c. 1860. The Dodge house was moved back along Campbell Street behind the Berkshire, which then came to occupy the east-side yard. Dodge was the original owner of the Dodge Lumber Mill, which was reportedly the largest sawmill operation in the world. Dodge left Williamsport with his brother and partner during the Civil War and never returned to town. (T. S. Meckley collection.)

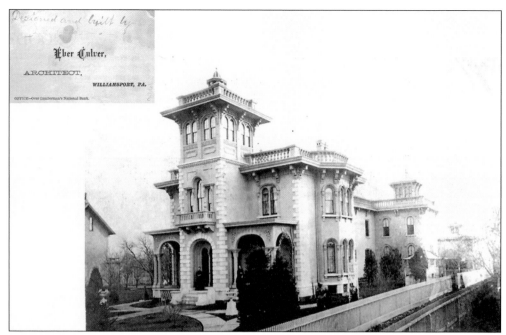

Eber Culver, the eminent architect who was responsible for most of Williamsport's greatest structures, was especially proud of the celebrated Million Dollar Mansion. He designed the building for millionaire lumberman and fellow architect Mahlon Fisher. In fact, Culver posted the image shown on this rare business card. The Italianate masterpiece was finished in 1866, boasting large cupola towers that offered views of the side and rear gardens of the estate. (Taber Museum collection and T. S. Meckley collection.)

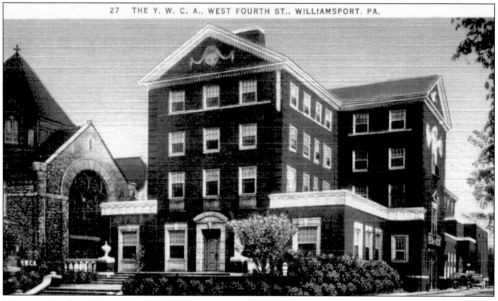

The YWCA building was constructed on the side of Mahlon Fisher's Million Dollar Mansion. After Fisher's death at his home on December 28, 1874, the Fisher family lived there until the 1920s. The extraordinary Victorian masterpiece stood vacant for a few years until its sale and eventual demolition. (T. S. Meckley collection.)

54

FOR SALE!
Twenty New Buildings,

NOW BEING ERECTED, IN CHOICE LOCATIONS, WITH
ALL THE MODERN IMPROVEMENTS,

UNDER THE SUPERVISION OF

E. CULVER, Architect.

POSSESSION GIVEN THE FIRST OF APRIL.

Price from $5,000 to $8,000,

ON FAVORABLE TERMS.

WILLIAMSPORT, PA. P. HERDIC.

(OVER.)

A postcard found locally describes 20 new buildings for sale, being developed and designed by the famous duo Peter Herdic and Eber Culver. It is not known if this is an authentic piece, but the postcard offers great insight and information on their work. (Private collection.)

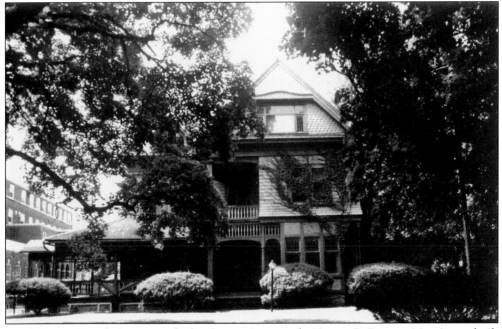

At 829 West Fourth Street stands the Queen Anne–style Henry C. Parsons Mansion, rebuilt from the former Benjamin Taylor dwelling, which was devastated by a fire. A Brown University–educated lawyer, Parson served as Williamsport mayor in 1881 and as president of the West Branch Bank of Williamsport starting in 1882. The Civil War veteran had five children to fill this enormous homestead. (Calaman collection.)

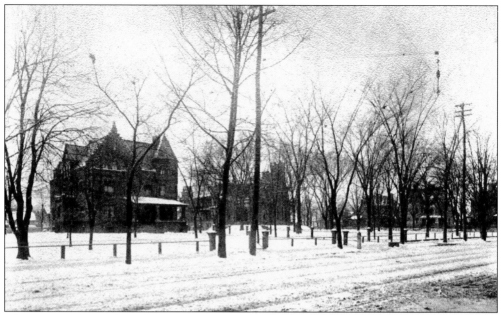

This amazing winter view shows the William and Mary White (Gamble) Emery stone edifice at 835 West Fourth Street in the foreground with its now demolished neighborhood and White's Castle along with the still standing Victorian homes along Maynard street. The 30-room home was purchased in 1906 by Seth T. Foresman, who was elected mayor of Williamsport in 1905. (Sprunger collection.)

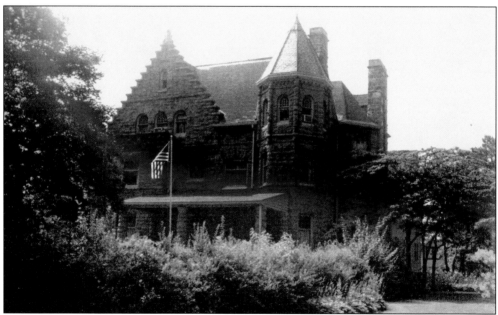

A close-up view of the Emery Estate looks almost exactly the same today as it did when it was built in 1889. The height of Victorian splendor and glamour resonates from the magnificent oak and cherry woodwork, elegant chandeliers, outstanding fireplace, and breathtaking stained-glass windows throughout the building. (Calaman collection.)

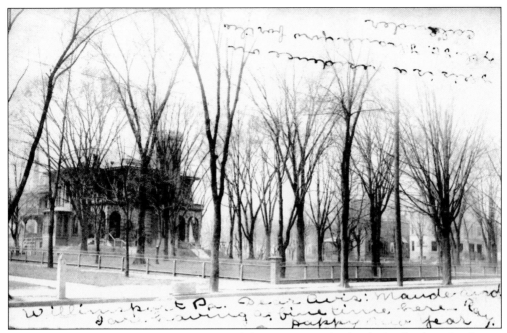

Another extremely rare real picture postcard shows a view of White's Castle, the Nice-Porter home at 329 Maynard Street, and the Amos S. Wagner house at 335 Maynard Street. Wagner was one of the leading architects in Williamsport, having designed many prominent commercial buildings and residences there during the Victorian era. (Sprunger collection.)

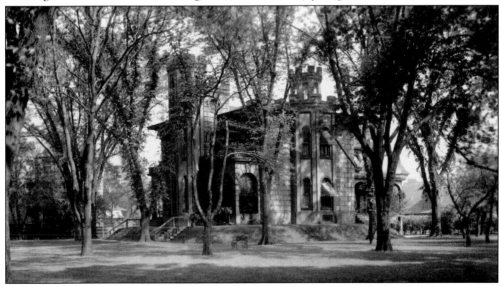

This unusual real picture postcard illustrates the massive stucco and brick structure (later known as White's Castle) that was built *c.* 1855 for engineer Robert Faries, superintendent of the Pennsylvania Railroad. Pioneer Williamsport lumberman John White and his family lived here for 60 years. White, together with his brother Henry, was a partner of Peter Herdic's in the lumbering firm of Herdic, Lentz, and White. Herdic had purchased the eclectic Victorian structure in March 1866 for $25,000 as its second owner prior to White's ownership. (Taber Museum collection.)

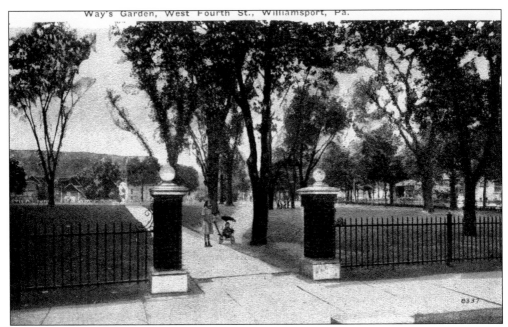

Local folklore has claimed for years that Way's Garden namesake and donor J. Roman Way had the fabled castlelike domicile destroyed because a potential buyer sought to purchase the building and use it for a house of ill repute. In reality, the buyer had intentions of making it a rooming house, which did not fit appropriately into this upscale neighborhood. In 1913, Way presented the house to the city of Williamsport in the form that it is known today, Ways Garden. (T. S. Meckley collection.)

Famous for their Victorian-era floral offerings, the Evenden Brothers—nurserymen, florists, and market gardeners—offered this trade postcard to showcase their sale of Easter lilies. The postcard was sent to Mrs. J. Roman Way. (DiBartolomeo collection.)

In 1884, Judge John W. Maynard donated Trinity Church's adjoining lot for a rectory. Then, in 1914, lumber baroness Amanda Howard donated the funds for Trinity Church's parish house. The lumber for the rectory appears to be lying on-site, ready for workers to begin. Next door, the enlarged (redesigned three-bay Federal-style brick farmhouse) Maynard Mansion and its cupola-topped carriage house are shown. (Stetts-Maietta collection.)

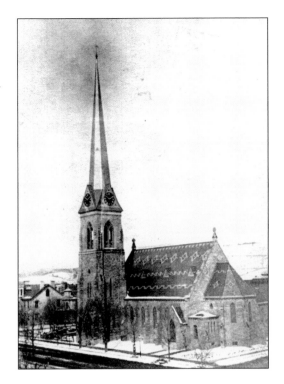

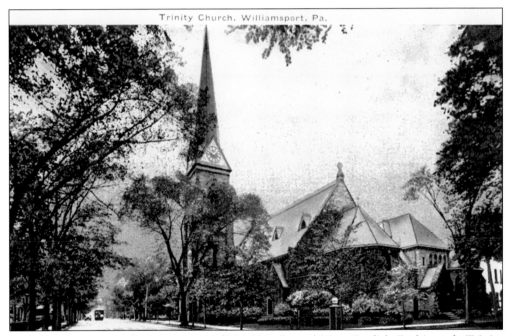

Built between 1871 and 1876 at a cost of $80,000, the ambitious English Gothic–style Trinity Episcopal Church was designed by Williamsport architect Frederick G. Thorn. Thorn moved to Philadelphia (attaining much success there), and fellow Williamsport architect Eber Culver completed the project, designing the magnificent spire. (T. S. Meckley collection.)

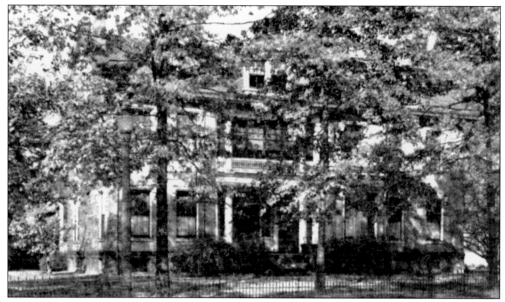

In 1939, the Maynard-Way Mansion became home to the Lycoming County Historical Society, which opened its museum in 1941. The period shown here is after J. Roman Way removed the two side wings with cupolas and the Gothic-style crenellated tower and trim details. He also remodeled the interior extensively after purchasing it in 1901. The Colonial Revival–style mansion burned down on December 22, 1960, and was replaced by a contemporary, fireproof masonry structure in the late 1960s. (Taber Museum collection.)

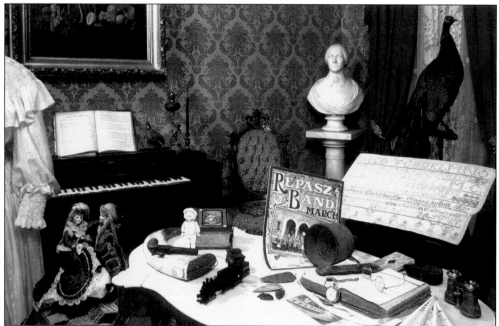

While many artifacts were lost in the December 1960 fire, many more were rescued and saved for the enjoyment of generations. Examples of Victorian life are exhibited on this Lycoming County Historical Society postcard, sold at the (renamed) Thomas Taber Museum in its gift shop. (T. S. Meckley collection.)

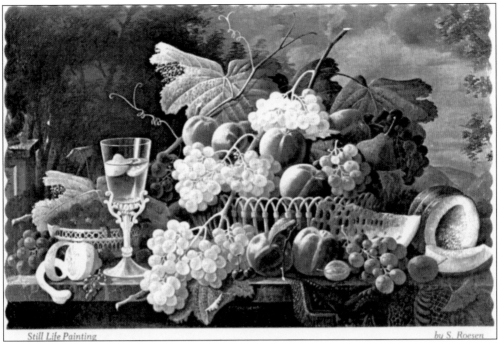

Still Life Painting *by S. Roesen*

Shown are two still lifes done in Williamsport by world-renowned German-born (1815) artist Severin Roesen. Roesen was most prolific during the time he spent in Williamsport (1860–1872). Roesen traded paintings and painting lessons with well-to-do Williamsport patrons for room and board (as well as local beer). He died from unknown causes sometime thereafter, having disappeared perhaps to New York City, where it is believed he is buried. (T. S. Meckley collection.)

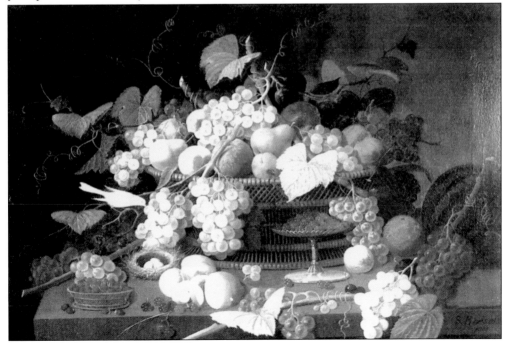

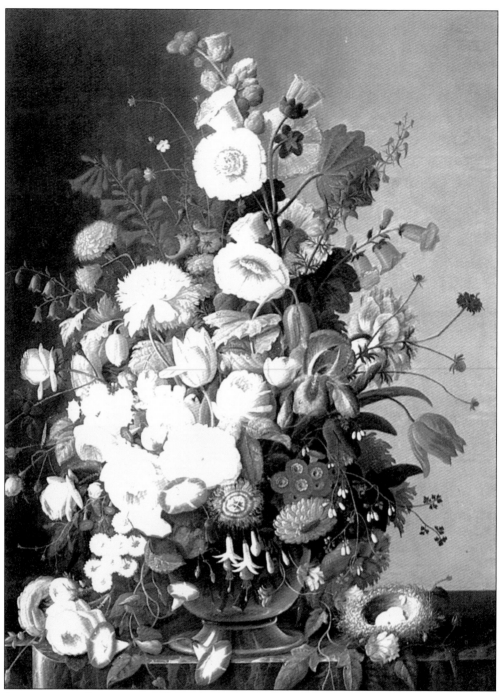

Severin Roesen's work went virtually unnoticed in the United States until nearly 100 years after his death when Jacqueline Kennedy hung one of his works in the White House during her famous restoration of the building. In Williamsport, scores of his works were passed down through generations of local residents. Dozens were burned in earlier times when they were found and removed during storage unit cleanings at local businesses such as the Flock Brewery. (T. S. Meckley collection.)

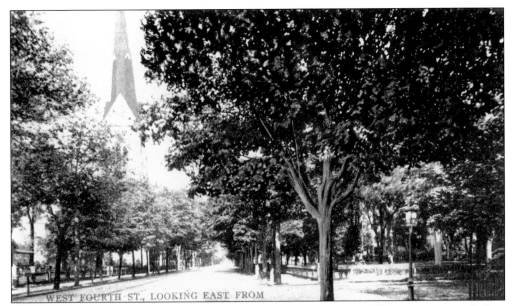

A timeless view of West Fourth Street is captured on this vintage Williamsport postcard. One can almost hear the toll of Trinity Episcopal Church's bell chiming. Peter Herdic donated not only the land but the Trinity Church building deed as well, while his father-in-law, Judge John W. Maynard, contributed the Cambridge quarter-hour chimes on Christmas Day 1875. The chimes were the first ever in the United States. (T. S. Meckley collection.)

The three-storied French Gothic at 907 West Fourth Street was built in 1890. It replaced the earlier Samuel and Emma (Otto) Filbert home, which appeared much like 915 West Fourth Street, the wedding gift to their daughter Lucy and son-in-law John L. Eutermarks. Both Italian Villa–style homes were designed by Eber Culver. The Timothy S. Clark Mansion at 907 West Fourth Street has been attributed to Culver as well, but during research for this book it was discovered that Truman P. Reitmeyer was the true architect. (T. S. Meckley collection.)

Relished architectural relics of Williamsport's Victorian era are featured on this contemporary card. Mansions at 901, 907, and 915 West Fourth Street are captured in their 21st-century setting. (T. S. Meckley collection.)

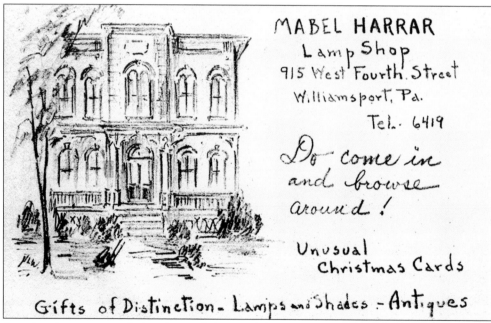

MABEL HARRAR
Lamp Shop
915 West Fourth Street
Williamsport, Pa.
Tel. 6419
Do come in and browse around!

Unusual Christmas Cards

Gifts of Distinction - Lamps and Shades - Antiques

A quaint vintage postcard advertises Mabel Harrar's lamp and antiques shop. A daughter of second owners Mr. and Mrs. Elwood S. Harrar, Mabel lived at 915 with her fellow unmarried sisters, Emilie and Lillian. After their passing, present owner Robert Esposito bought the ailing 1870s Italianate building. Esposito restored and renovated the 11-room home, showcasing Victorian-period décor in an impeccable manner. (DiBartolomeo collection.)

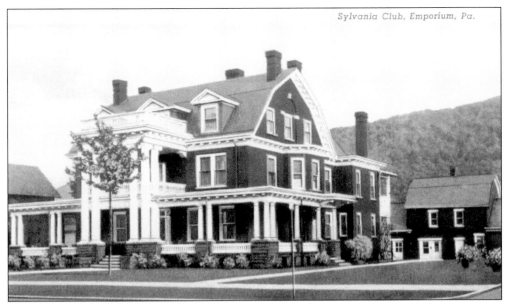

The Henry Auchu Mansion (later the Sylvania Club) of Emporium, Pennsylvania, served as the model for Williamsport's 912 West Fourth Street mansion. Visually, the two look identical except for the fact that the Williamsport version has its left front porch clipped back to one, not two, sections. Its builder, Henry Melick Foresman, was the general manager for the Williams and Foresman Lumber Company, which employed Auchu in Emporium in a similar capacity. (T. S. Meckley collection.)

This simple Gothic Victorian at 928 West Fourth Street was the home of David Tuttle Mahaffey from around 1885 until the turn of the century. This real picture postcard is most likely from the period when the Charles Weis family lived there (1900–1917). Mahaffey was chairman of the Williamsport Kindling Wood Company at 228 Locust Street. His brother, Delos S., lived next door at 918 West Fourth Street and served as company treasurer. (Ackerman Estate collection.)

One of Millionaire Row's foremost citizens, J. Henry Cochran lived at 945 West Fourth Street (second from right) for a number of years. Cochran was an accomplished financier, railroad and industrial leader, lumberman, and state senator. His lumber concerns involved the firms of Ryan, Cochran and Company and Payne, Cochran and Company. Further, he bought John G. Reading's interest in the famed Susquehanna Boom Company. (Kane collection.)

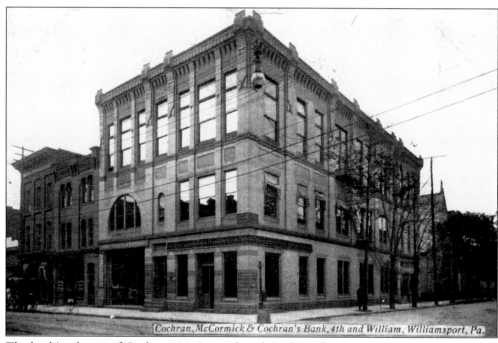

Cochran, McCormick & Cochran's Bank, 4th and William, Williamsport, Pa.

The banking house of Cochran, McCormick and Cochran first began as the Cochran, Payne and McCormick Bank. J. Henry Cochran organized the first with fellow lumbermen Henry C. McCormick and Eugene R. Payne. Later, its name became the Northern Central Trust Company. (T. S. Meckley collection.)

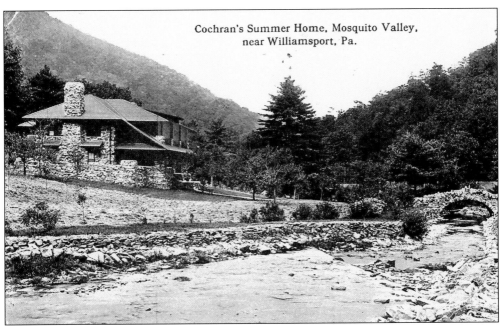

Cochran's Summer Home, Mosquito Valley,
near Williamsport, Pa.

J. Henry Cochran's wealth afforded him such spoils as this stone-faced summer retreat in nearby Mosquito Valley. Widely respected and well liked in Williamsport's social circles, Cochran was a modest man, who included Pres. Grover Cleveland among his friends. Cochran declined nominations for the governor of Pennsylvania and was a nominee for U.S. senator on several occasions. (Above, Daniel Bower collection; below, Stetts-Maietta collection.)

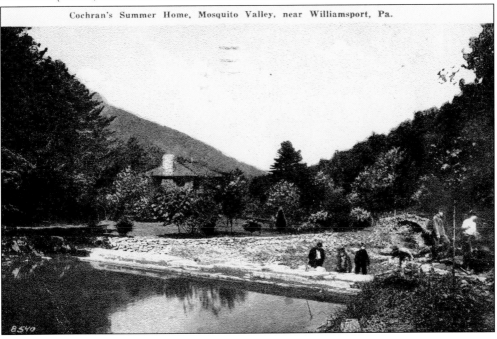

Cochran's Summer Home, Mosquito Valley, near Williamsport, Pa.

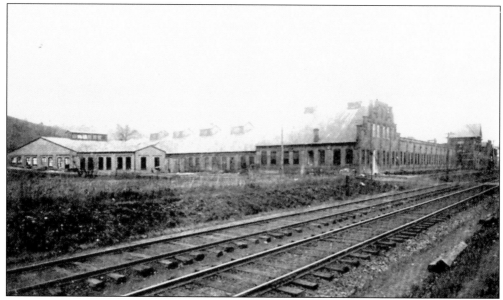

When the lumber business began to wane in Williamsport, J. Henry Cochran led the movement to diversify local industry concerns. Cochran invested in the Lycoming Foundry and Machine Company and the wire rope plant in town, to name a few. In fact, he took an interest in nearly every industry the newly formed board of trade brought to Williamsport. (Daniel Bower collection.)

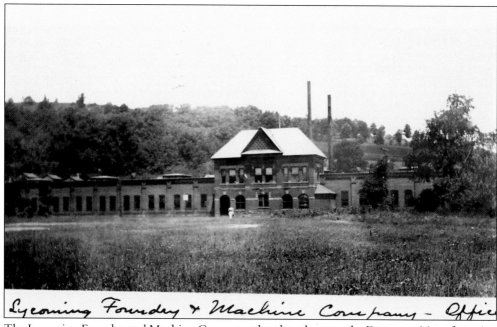

The Lycoming Foundry and Machine Company plant later became the Demorest Manufacturing Company site. Demorest made sewing machines and bicycles. Cochran, president of the Lycoming Foundry and Machine Company, was regarded as a power player in banking, electric and steam railroads, and various other commercial and industrial trades. (Daniel Bower collection.)

Known as the Cleveden, the building at 949-951 West Fourth Street was built between 1865 and 1870 by banker and lumberman George W. Lentz. The Italianate and French Second Empire mansion is, however, typically associated with lumber baron Robert McCormick Forsman. The Queen Anne–style roof replaced an original mansard roof, which was destroyed by a fire in the early 1880s. Many original interior features remain throughout the illustrious building today. (Calaman collection.)

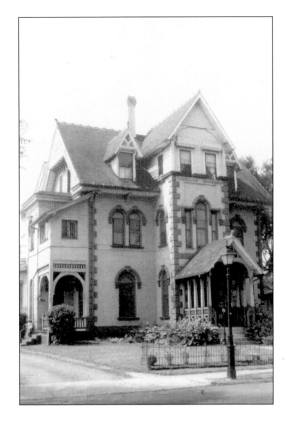

Evidence of Williamsport's wealth is exemplified by the illustrations of the Victorian mansion shown here during the early part of the 20th century. Note the gingerbread-decorated porches on each structure. Unfortunately, most of these porches are gone today. (Private collection.)

This impressive 1860s English Gothic–style Victorian building at 1005 West Fourth Street was owned by Peter Herdic, John Reading, and H. E. Taylor until wholesale grocer John E. Goodrich purchased it. Goodrich, who dabbled in the lumber trade in the firm of Goodrich and Taber, lost his home at a sheriff's sale during the Panic of 1878. Later, the mansion was owned by Annie Weightman Walker Penfield, who reigned as the richest woman in the world in her day. (Private collection.)

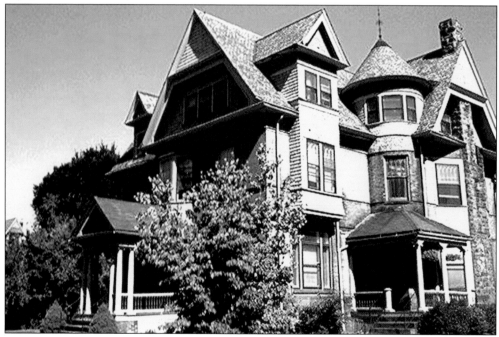

Known as the Jayne Apartments, 1006 West Fourth Street was built by John J. Metzger. The mammoth three-story brick Metzger Mansion sits on land occupied by the former Hiram Mudge house, which was moved to the rear of the lot and now faces Fifth Avenue. Today, the building serves as apartments for Pennsylvania College of Technology students. (T. S. Meckley collection.)

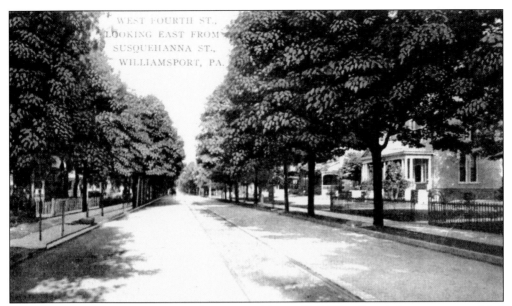

Originally built as a late 1860s Second Empire residence, 1063 West Fourth Street was remodeled in the Colonial Revival–style in the 1980s with its new defining gambrel roof. The original Italianate window heads give clues to its earlier appearance. (T. S. Meckley collection.)

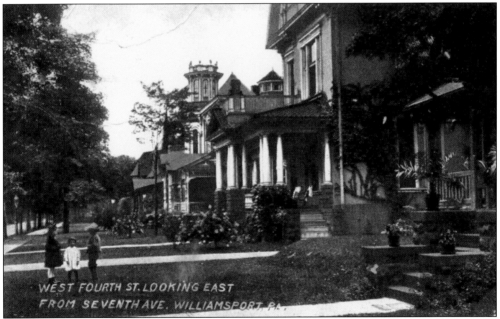

Upper Millionaire's Row is shown here during the early part of the 20th century. Much of its Victorian appeal and grace is still intact today. The brick-paved street is marked by the trolley lines, which were electrified in 1893. In June 1895, Mrs. Nelson Byers (age 40) and her young grandson were killed on these tracks near this very spot. Byers went to retrieve the child, who had wandered out to the tracks, but an oncoming streetcar struck both of them. Mr. Byers, a leading local lumberman, was away on business. (T. S. Meckley collection.)

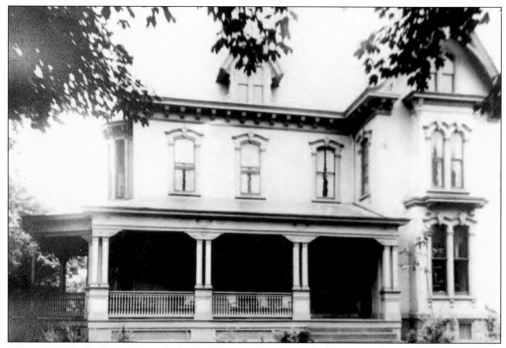

The *c.* 1880 E. R. Payne house is depicted here as it appeared after its porch was remodeled by the Brooks Reese family in the early 1900s. Payne was a prominent banker and lumberman, serving as secretary of the Susquehanna Boom Company at one time. Brooks Reese Sr. was one of the later participants in the lumbering business in Williamsport. (Brooks Reese family collection.)

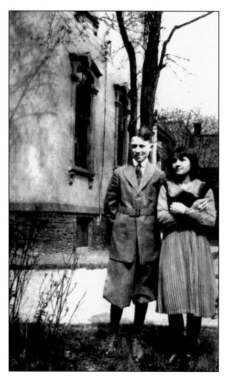

Brooks Reese Jr. and his sister Lola Rae pose beneath the ornate window details of the Payne-Reese Mansion. Nearby, the Reese family enjoyed one of the first tennis courts in Williamsport, right in their own backyard. (Brooks Reese family collection.)

Rae Spangle, granddaughter of lumberman Brooks Reese Sr., readies for her spin in the snow along West Third Street. The large brick home in the background was built *c.* 1894 by *Grit* founder Dietrich Lamade, who lived there with his second wife until his death. (Brooks Reese family collection.)

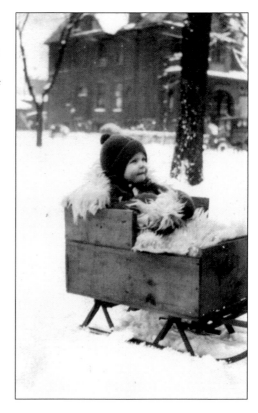

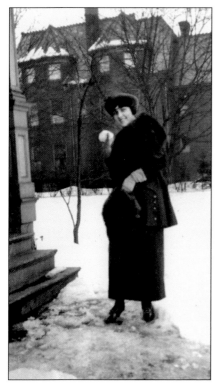

Stylish Lola Rae Reese, daughter of wealthy lumber dealer Brooks Reese Sr., frolics in the snow at the rear of the Payne-Reese Mansion at 1151 West Fourth. The massive brick mansion in the background is that of the now demolished William Howard Mansion, located at 1139 West Fourth Street. (Brooks Reese family collection.)

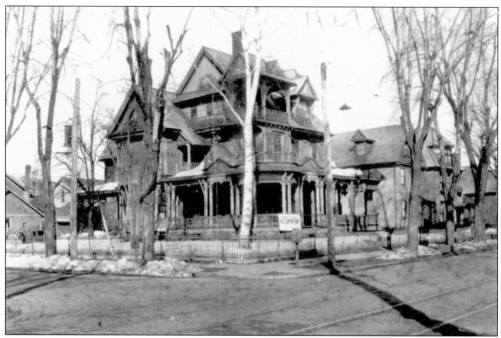

Local historian Samuel Dornsife used to quip that S. N. Williams's home at West Fourth and Rose Streets was proclaimed in its day "to have a $700 porch built on a $400 house." Williams was the only local boy to succeed during the lumber era. Aside from his lumber and other business ventures, Williams served as Williamsport's 14th mayor. (Kane collection.)

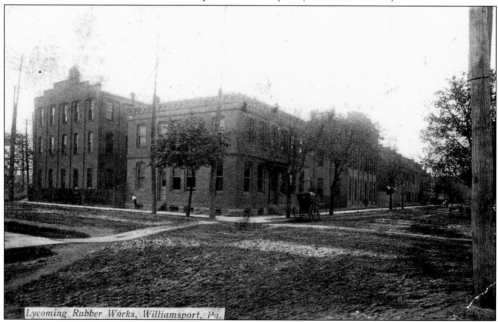

The Lycoming Rubber Works was run by Samuel N. Williams, who was born and raised two blocks away, building his own large Victorian mansion one block south. The plant has been quoted as having employed 252 employees, but at a closer look, this figure did not include the 150 women and young girls who worked (and lived) there. (T. S. Meckley collection.)

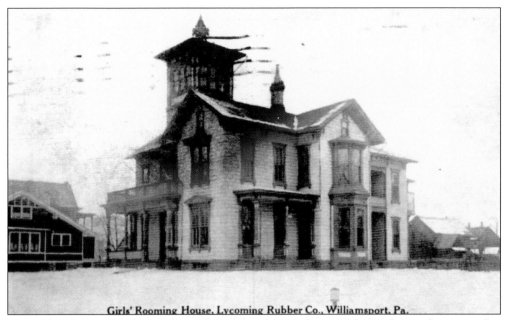

Young female employees were housed near the plant at this modified Italianate home, used as the Lycoming Rubber Company's rooming house for women. (Kane collection.)

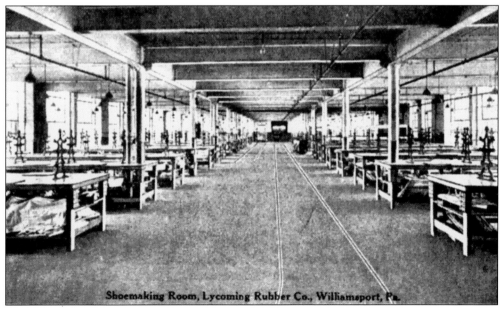

S. N. Williams was the founder of the Lycoming Rubber Company (later known as the U.S. Rubber Company). Manufacturers of rubber boots and shoes, the plant was the largest producer of Keds in the United States. The company later moved to New York State, which hit the Williamsport economy hard as the town struggled during the post-lumber era years. (Stetts-Maietta collection.)

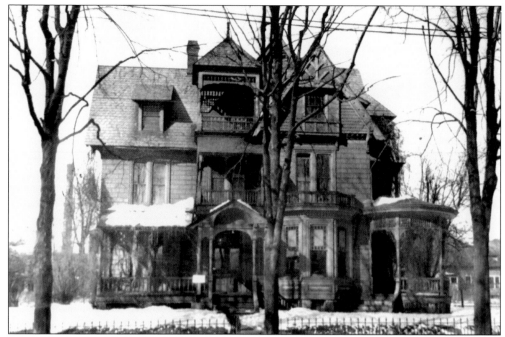

Now named the Gargoyle, the Seth T. Foresman Mansion has been saved from demolition and remodeled by the Hutchinson Realty Development Company. It serves as off-campus apartments for Pennsylvania College of Technology students. (Hutchinson collection.)

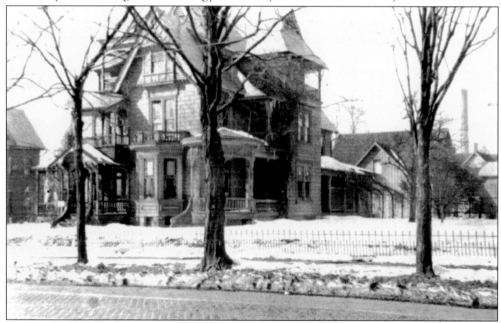

Seth T. Foresman raised his family here at the end of Millionaires' Row at 1314 West Fourth Street before moving a few blocks down to 835 West Fourth Street in 1905. Foresman lived at home on the farm until age 26 to help support his family. He went on to become a schoolteacher, college-educated student, Civil War soldier, contractor, manufacturer, entrepreneur, leading lumberman, Williamsport mayor, and staunch Democratic politician. (Kane collection.)

Four
THE BOOM DYNASTY

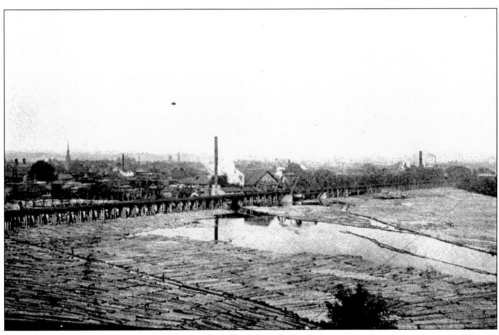

Not too long after Peter Herdic's arrival in 1853, Williamsport emerged from a tiny, slumbering town with a few small mills to a bustling lumber center, operating 30 sawmills and producing 318,342,712 feet of board from 1,582,460 logs in 1873. Industries were started here as offshoots of the lumber trade—furniture, musical instruments, sheet music, and tanneries, for example—by those flocking to join the lumber frenzy and make their fortunes. Once established among Williamsport's elite, many sought to build their West Fourth Street mansions along the fabled Millionaires' Row. (T. S. Meckley collection.)

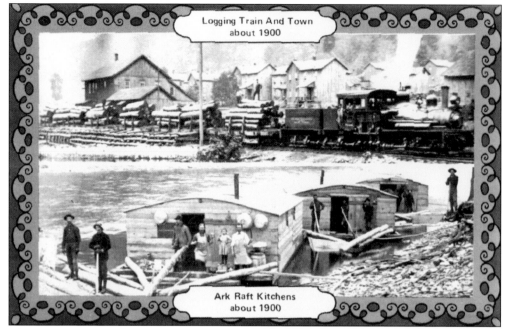

Logging Train And Town
about 1900

Ark Raft Kitchens
about 1900

This souvenir postcard was given out for many years to patrons at the Hasson family's City View Motel. It depicts various long–ago local lumbering scenes as logs were transported to the mighty Williamsport mills and factories. (DiBartolomeo collection.)

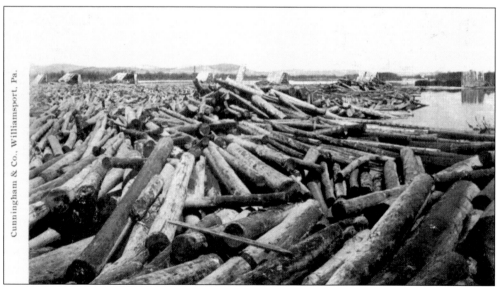

Cunningham & Co., Williamsport, Pa.

Peter Herdic, Mahlon Fisher, and John G. Reading operated the Susquehanna River Boom. They signed a simple, 300-word agreement that shaped the fortunes and destinies of themselves and Williamsport, which come to be known as "the Lumber Capital of the World." (Daniel Bower collection.)

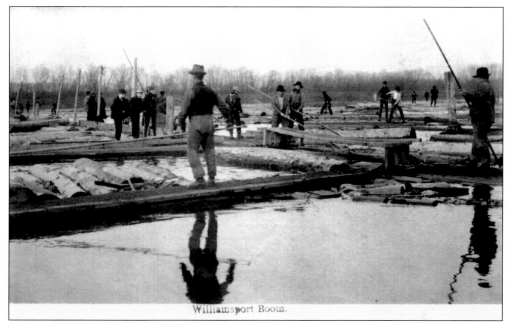

"River rats," as boom workers on the Susquehanna River were called, sort the branded logs according to some 17,000 marks for each individual lumber interest. Boom owners charged a toll for each log, amassing millions. When they increased the toll from 75¢ to $1.25 per 1,000 feet, their annual income was over $225 million. (Ackerman Estate collection.)

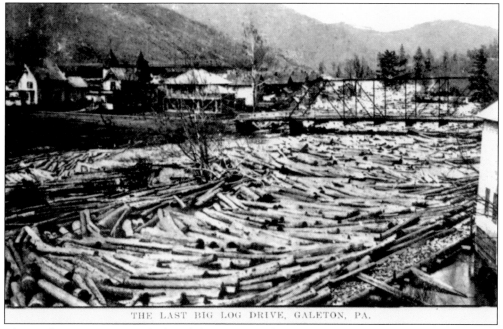

This Williamsport-postmarked card shows a typical log drive from one of the outer harvesting locations. Here, timber was cut far to the north of Williamsport, where it was eventually floated downstream to the river mills. (Ackerman Estate collection.)

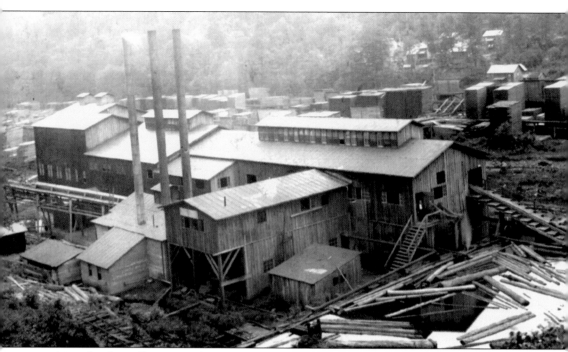

Many lumbermills came and went over the years due to buyouts, fires, bankruptcies, and move-outs. Two of the mills from the industry's heyday are shown on these pages. One of the largest and most well-known mill was that of Brown, Clark, and Howe. The mill was run by Stephen and Orange Brown, who lived in the now demolished building at 605 West Fourth Street; Timothy

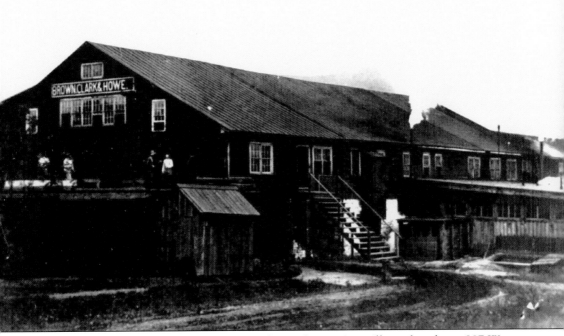

S. Clark, whose West Fourth Street French Gothic-style mansion still stands today at 907 West Fourth Street; and David A. Howe, who lived in various mansions along West Fourth Street as well as being a guest at the Herdic House and the Updegraff. (Stett-Maietta collection.)

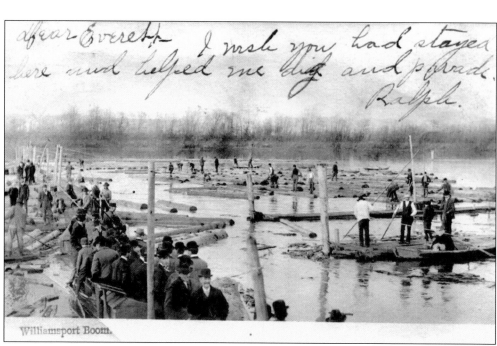

Dear Everett— I wish you had stayed here and helped me dig and parade. Ralph.

Williamsport Boom.

Another rare real picture postcard is shown from Williamsport's lumber era. This was the actual print used to make the postcard below, which was produced in color. (Above, DiBartolomeo collection; below, T. S. Meckley collection.)

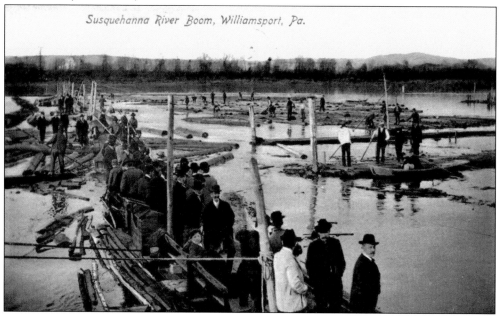

Susquehanna River Boom, Williamsport, Pa.

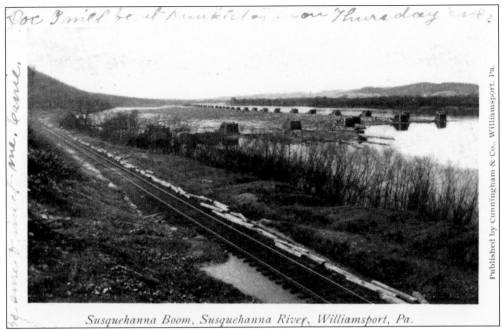

Published by Cunningham & Co. Williamsport, Pa.

Susquehanna Boom, Susquehanna River, Williamsport, Pa.

The Susquehanna boom was 17 miles long. The first of its designs was destroyed by the floods of 1860 and 1861. It was replaced by a new improved boom designed by Peter Herdic. He used a system of cables and sunken cribs. It successfully withstood the Great Flood of 1865 but was no match for the flood of June 1889. Sadly, the flood destruction and environmentally neglectful lumber practices of the region led to the lumber trade moving away to other parts of the United States and South America. (T. S. Meckley collection.)

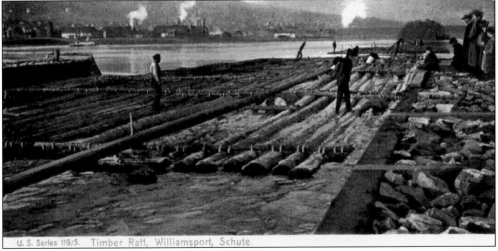

U. S. Series 119/5. Timber Raft, Williamsport, Schute.

This card shows the mills and factories along the Susquehanna as well as the river's boom while "river rat" workers construct a timber raft. These were made of specialized timbers that were sold downriver, after which time they were made into ship masts. The proceeds from the timbers of the raft paid for their return trips (in addition to the profits from the logs they floated downstream). The short quote from the back of the card, dated April 26, 1909, finishes the story: "Dear Grandma: This used to be a great lumber district but the timber is about gone now Ralph." (DiBartolomeo collection.)

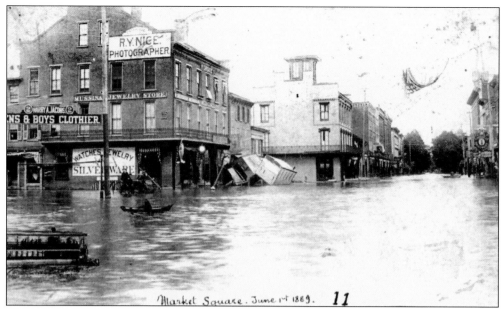

This rare real picture postcard documents Market Square during the flood of June 1889. The view looks east along Third Street, showing the merchant shops of Mussina's Jewelry, R. Y. Nice Photography Studio, and Kline's Hardware. (Carson collection.)

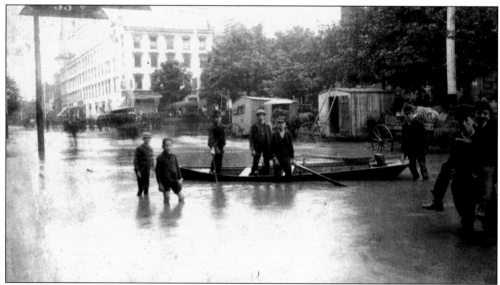

Downtown Williamsport merchants and hoteliers were affected by the June 1889 flood. Note the newly renovated L. L. Stearns and Sons building in the background, where the store had just relocated to in 1888. The famed local R. Y. Nice photography studio (below, left) looks like it may have fared better than neighboring James N. Kline's hardware outfit (below, right). (L.L. Stearns family collection.)

Stacked boards of Williamsport's famed white pine and hemlock from the nearby lumberyards wreaked havoc along West Third Street, as illustrated in these two real picture postcards showing the June 1889 flood. (DiBartolomeo collection.)

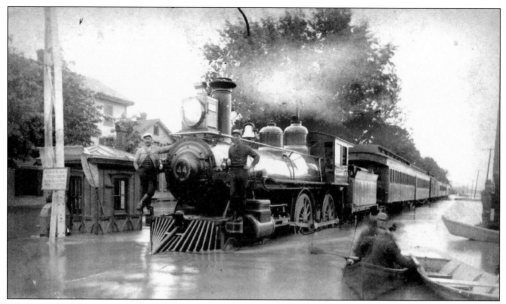

This view of the June 1889 floodwaters in downtown Williamsport captures crew members of Philadelphia and Reading locomotive No. 44. (Taber Museum collection.)

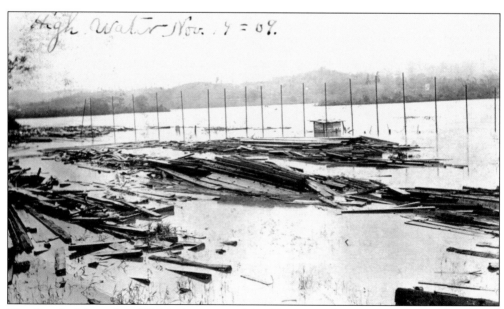

Flooding in November 1909 is documented in this rare real picture postcard of the boom in the Susquehanna River. This is near the end of the famed lumber era in Williamsport. (Stetts-Maietta collection.)

Five

VALLAMONT

Picnic Grounds, Vallamont Park, Williamsport, Pa.

The park picnic grounds were found in the heart of Vallamont. The developers offered prospective buyers a look to the east, "beautiful drives around Grampian Hills and the Boulevard;" to the north, natural forestlands; to the west, "a restricted residence section that is unexcelled for beauty and grandeur"; and to the south, the "Ideal City–Williamsport." (Sprunger collection.)

A serene view is pictured from within Vallamont Park of the entrance to the trolley station. (Carson collection.)

Entrance to Vallamont Park Williamsport, Pa.

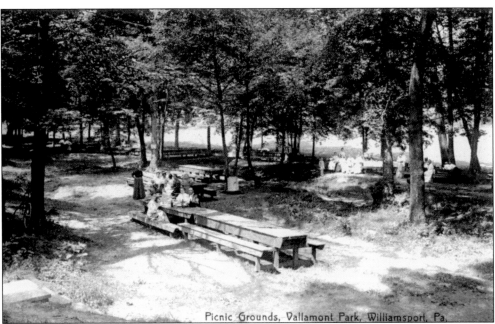

Picnic Grounds, Vallamont Park, Williamsport, Pa.

Three different groups of Victorians are shown partaking of local beer and basketed feasts. The picnic ground grove offered a cool haven to relax alongside long picnic tables and benches. (Fullmer collection.)

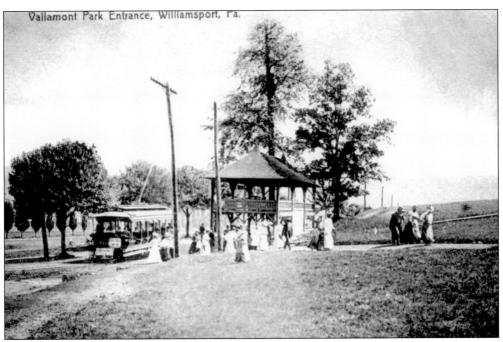

Vallamont Park Entrance, Williamsport, Pa.

Visitors to Vallamont Park board the East End Trolley at the days end. Serviced by the Vallamont Traction Company, the station marked the park entrance, sitting at the north end of Woodmont Avenue on the west side. The fare for a trip from town was just 5¢. Black bears roamed the park area, as they continue to do today—but not as plentifully. (Above, Sprunger collection; below, Reuel Hartman collection.)

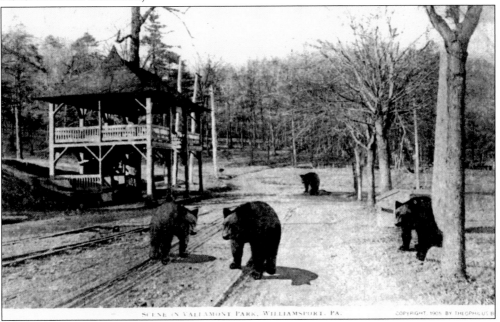

SCENE IN VALLAMONT PARK, WILLIAMSPORT, PA. COPYRIGHT, 1905, BY THEOPHILUS B

For many years, this was the site of the Vallamont Park theatrical pavilion for open-air summer performances. In 1897, Gilbert and Sullivan's *H.M.S. Pinafore* was staged. A ticket for the matinee cost a nickel, and the evening show cost a dime. In early July 1921, the pavilion was relocated to the James N. Kline Boy Scout Camp along Pine Creek and served as a mess hall and reception pavilion. (T. S. Meckley collection.)

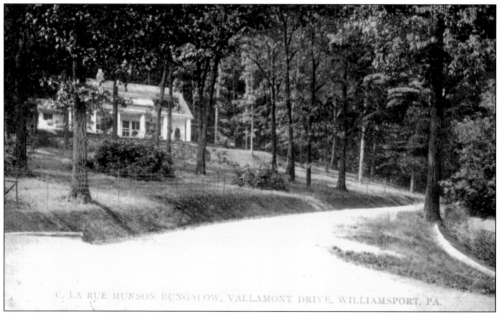

Cyrus La Rue Munson built his summer estate bungalow just west of Glen Echo Road where First Avenue intersects Vallamont Drive (now 860 Vallamont Drive). In later years, Munson, a famous lawyer and financier, moved here from his West Fourth Street mansion. He died on December 8, 1922, at the Rockefeller Institute in Peking, China. Today, the bungalow still stands, but additions over the years make it a much bigger structure than it once was. (Sprunger collection.)

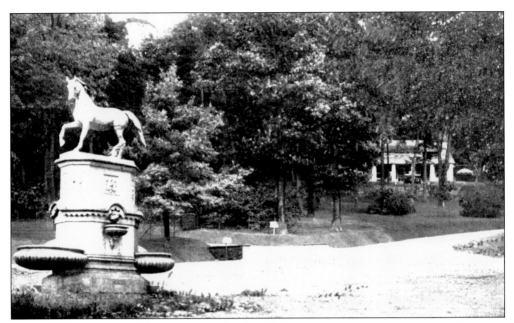

Adorned with a trotting horse on top, this fanciful cast-iron fountain was relocated at some point to sit along the Golden Strip in Loyalsock. Its whereabouts since it was removed from there remains a local mystery. (T. S. Meckley collection.)

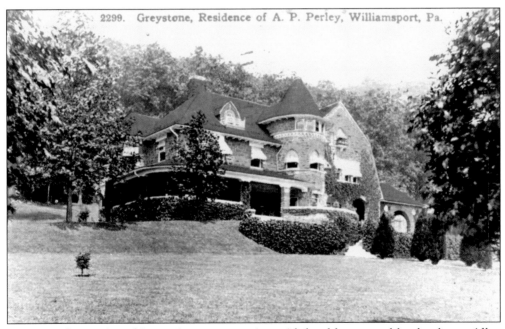

2299. Greystone, Residence of A. P. Perley, Williamsport, Pa.

Many people associate this massive stone mansion with local lawyer and lumber baron Allen Putnum Perley. However, it was fellow lawyer and businessman Charles R. Harris who originally built Greystone (now 820 Vallamont Drive) c. 1890. Perley rebuilt the mansion as it was after a fire destroyed the stone home in 1893. (T. S. Meckley collection.)

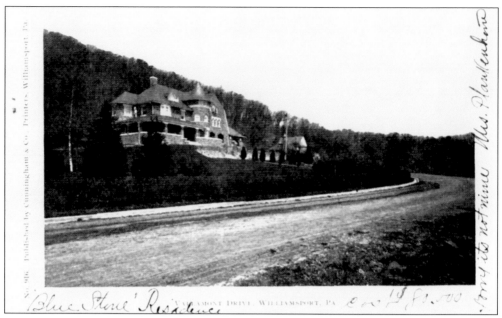

A recent research discovery by the author revealed that Greystone's architects were Eber Culver and Son (Eber and Newton) while they were working out of their office at 234 West Fourth Street. Note Mrs. Plankenhorn's comments and the change of the building's name. (Carson collection.)

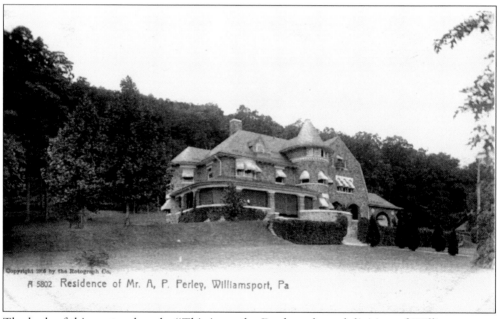

The back of this postcard reads, "This is on the Boulevard, a subdivision of Williamsport at one time. Charles Harris lived there. You no doubt saw his name on suspender buckles. He went in with a Jew and they had a big suspender factory. He claimed the Jew beat him then his house burned down everyone thought with his help. So the present owner built it up. He is in the lumber business. Hope you will like it. You have most all of the City views." It is signed by Clara. (T. S. Meckley collection.)

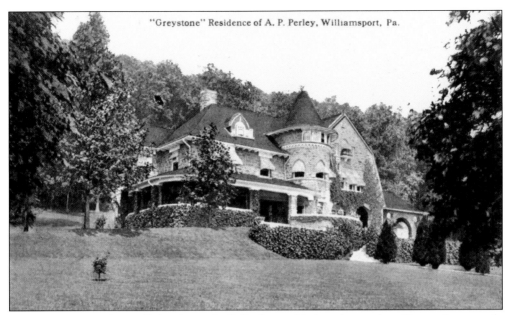

"Greystone" Residence of A. P. Perley, Williamsport, Pa.

For many years prior to living here, A. P. Perley resided at the modest Queen Anne–style mansion he built at 309 Campbell Street. The Perley family lived at Greystone until the 1930s. It was then that lots were sold off from the original Vallamont Drive lot, making building sites available from First Avenue and Glen Echo Road to Campbell Street. It was stipulated that the builder of Greystone could not put more than one dwelling on the $6,000 lot, nor could he build the house for less than $6,000. (T. S. Meckley collection.)

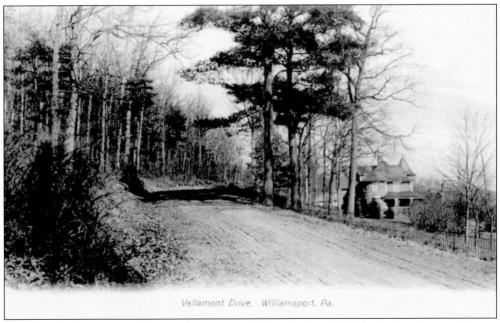

Vallamont Drive. Williamsport, Pa.

Advertised as having roads "smooth as racetracks" at the time of their design, the road shown here is Glen Echo Road looking down on Greystone's western side. (Fullmer collection.)

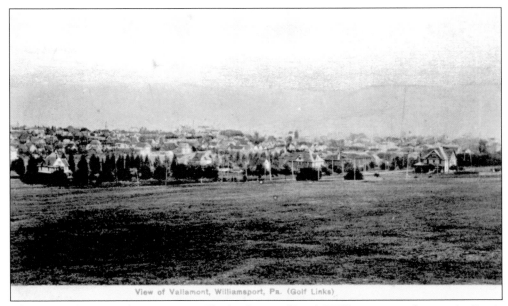

This postcard was sent from Mrs. Dan Plankenhorn, of South Williamsport, to her cousin Carrie Keebler. The nine-hole, par-three golf course depicted on the card was adjacent to Vallamont. (T. S. Meckley collection.)

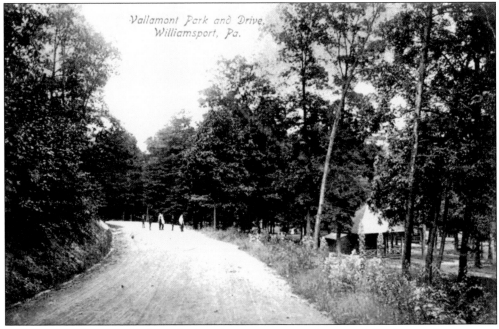

Vallamont Park was quite busy during the summer months, especially due to the open-air theater pavilion. The venue hosted many talented performers during the summer seasons with acts such as ventriloquists; medicine shows demonstrating cures for any disease known to man; glass blowers; and puppet shows (like Punch and Judy). (Fullmer collection.)

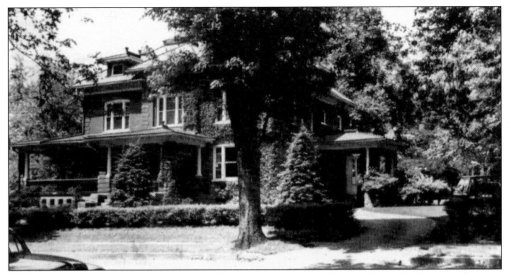

The Vallamont Mansion, at 1305 Woodmont Avenue, was the onetime site for the Florence Crittenton Home for girls during the 1950s. The Victorian and Arts and Crafts–style home was recently restored during the single-family occupancy of Thomas and Rebecca Burke. (Stett-Maietta collection.)

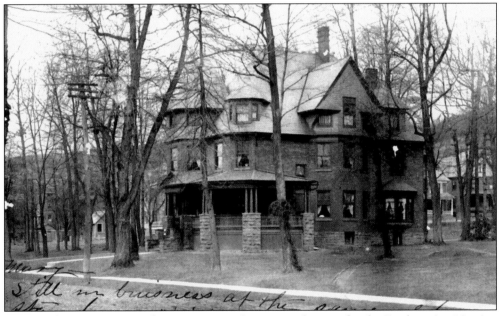

This stately 1896 Victorian house was torn down to make way for the Presbyterian Nursing Home facilities there at 820 Louisa Street. Horace A. Hanks, bookkeeper of the Sampson Q. Mingle Music House, and George Housel, manager of the Williamsport Brick Company, were the first occupants. (Taber Museum collection.)

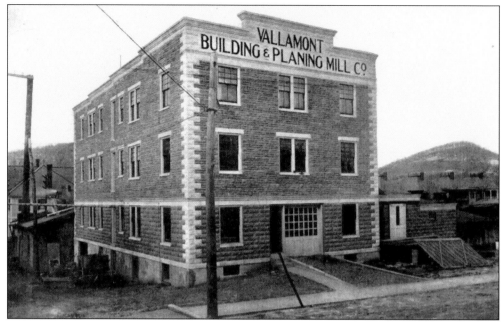

The Vallamont Planing Mill Company operated for many years on Market Street before becoming part of "twin" apartment buildings, which is how it is still used today. The building is very close to the Vallamont section, a planned development by local lawyer James Barber Krause. He plotted out the residential section from his purchase of the 400-acre Packer farm for the sum of $100,000 in 1889. (Stetts-Maietta collection.)

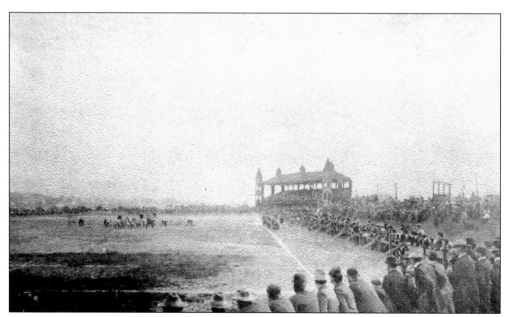

Vallamont's Athletic Park field is shown during a Bucknell University-Carlisle Indians football game. The J. Henry Cochran Elementary School occupies the site today. (Private collection.)

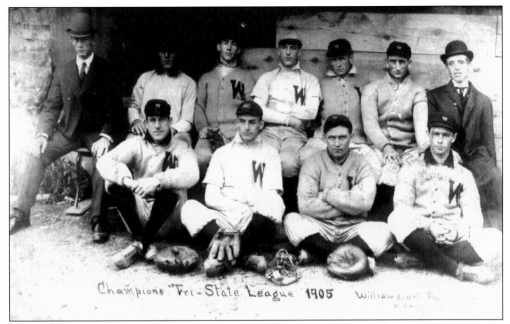

Williamsport won the Tri-State League championship title just one year after professional baseball was introduced to Lycoming County. (Taber Museum collection.)

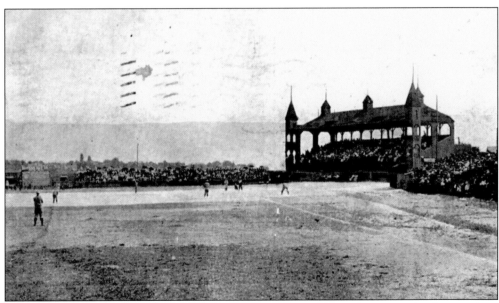

Williamsport joined Pennsylvania teams from York, Harrisburg, Altoona, and Lebanon along with teams from Wilmington, Delaware, and New York to form the Tri-State League. New Jersey joined later, although it was part of the league organization prior. This widespread field of teams made for exciting events at Athletic Park. (T. S. Meckley collection.)

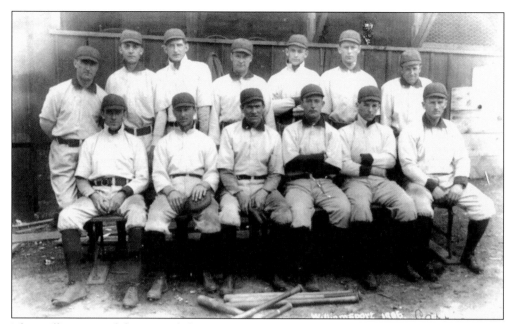

The Williamsport club acquired the name Millionaires due to the excellent financial support by Williamsport's affluent residents. Pennants were won by the Millionaires in 1906 and 1907. (Taber Museum collection.)

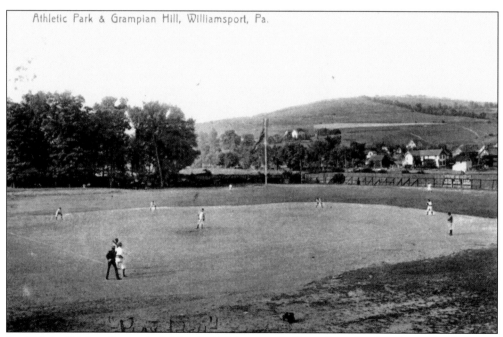

By 1910, the Tri-State League had disbanded. This postcard offers a view of a minor-league baseball game in action at Athletic Park, located at the foothill of Grampian Hills. (T. S. Meckley collection.)

Six

BYGONE DAYS

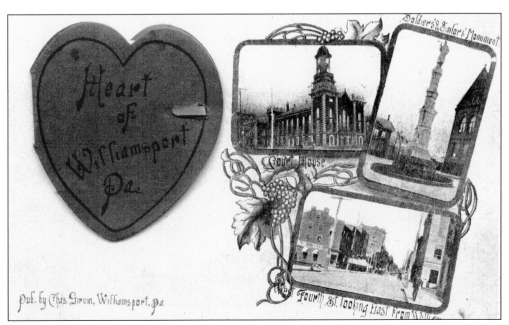

A quintessential Victorian keepsake postcard, this rare find showcases city views within its heart similar to those beside it. (Stetts–Maietta collection.)

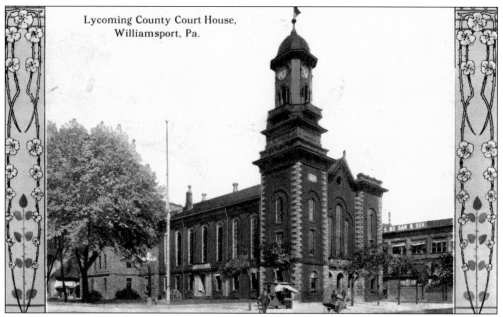

Lycoming County Court House,
Williamsport, Pa.

This fanciful card has a note from a young Market Day vendor. Mell tells her aunt, Mrs. Jennie Jamison, of 527 Eighth Avenue in Williamsport, "It may be a little late when I come for we are going to finish catering my goods. Mother is going to move on Monday and she takes my stove so I will have to vacate. I will be there by half past 9 not later." (Fullmer collection.)

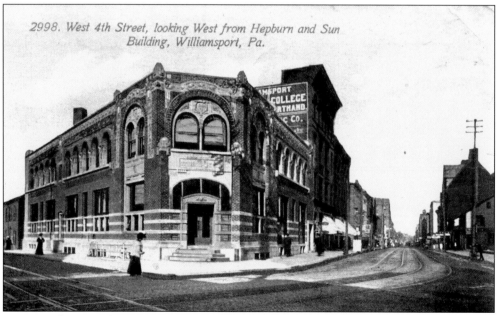

2998. West 4th Street, looking West from Hepburn and Sun
Building, Williamsport, Pa.

A view to the west of West Fourth Street, this card spotlights the brand-new Art Nouveau–style Sun-Gazette building, which has, like its product, become associated with its former longtime owners, the Person family, of Williamsport. (Fullmer collection.)

Publishers of this card and many others of the day, the Scholl Brothers could be found here, conveniently across from the federal post office. The Williamsport Commercial College was located in the upper floors of its building. Today the magnificent stone edifice serves as Williamsport's city hall. (Taber Museum collection.)

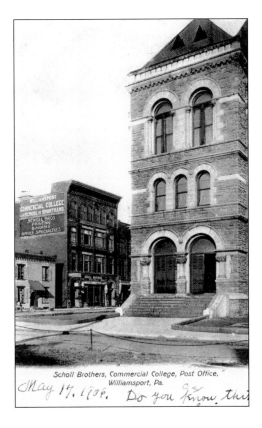

Scholl Brothers, Commercial College, Post Office, Williamsport, Pa.

May 17, 1906. Do you know thi

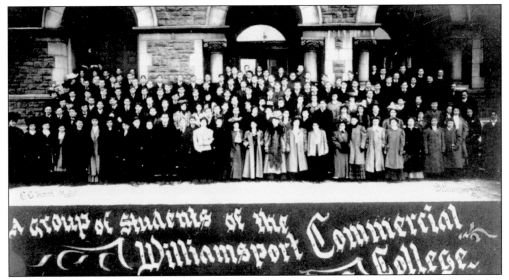

A group of Students of the Williamsport Commercial College.

Again, how convenient to have the post office right across from the school and the publisher of this postcard. Note the attractive close-up view of the post office's arched entryways in the background of this class picture. (DiBartolomeo collection.)

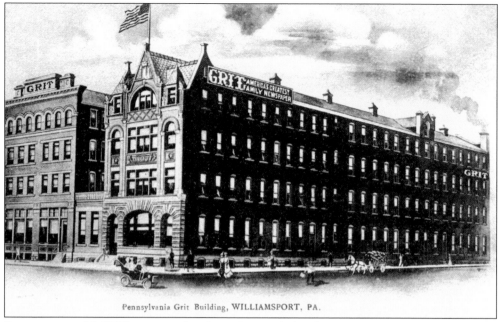

Pennsylvania Grit Building, WILLIAMSPORT, PA.

Synonymous with Williamsport, the *Grit*—America's family newspaper—was published here until the early 1990s, making it one of the nation's oldest newspaper publications. After 103 years, the Sunday paper ceased production when the national *Grit* was sold off to a midwestern outfit. Dietrick Lamade became one of Williamsport's millionaire success stories, having built his legacy from the ground up. (Carson collection.)

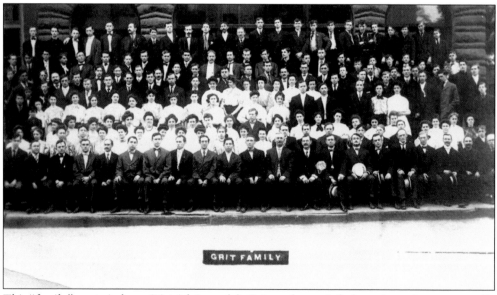

This "family" portrait shows Dietrick Lamade's *Grit* employees (of whom the author was proudly one of the last). The Lamade family lived in the modest mansion that Dietrick built at 746 West Third Street. It still stands today, just blocks up the street from the newspaper building. (DiBartolomeo collection.)

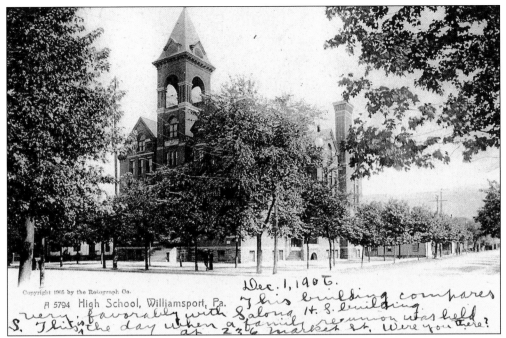

Copyright 1905 by the Rotograph Co.

A 5794 High School, Williamsport, Pa.

Dec. 1, 1906.
This building compares very favorably with along H. S. building. *This is the day when a family reunion was held at 236 Market St. Were you there?*

Designed by Eber Culver, the Central High School building sat at the corner of West Third and Walnut Streets. Built in 1887, the high school burned to the ground on April 3, 1914. (Above, T. S. Meckley collection; below, Daniel Bower collection.)

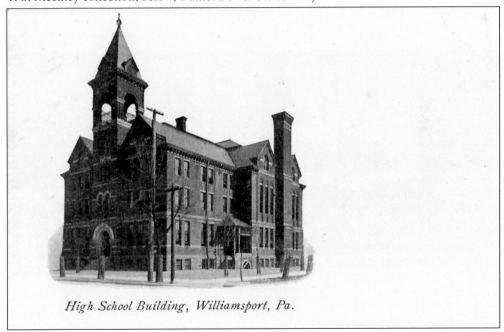

High School Building, Williamsport, Pa.

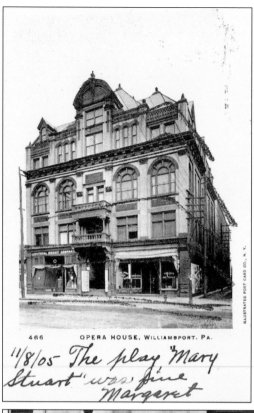

Another of Eber Culver's masterpieces, the Lycoming Opera House was one of the focal points in Williamsport cultural circles. It hosted the country's leading theatrical stars and minstrel companies of the day. Built in 1892, it was destroyed by a fire in 1915. (T. S. Meckley collection.)

466 OPERA HOUSE, WILLIAMSPORT, PA.

11/8/05 The play "Mary Stuart" was fine Margaret

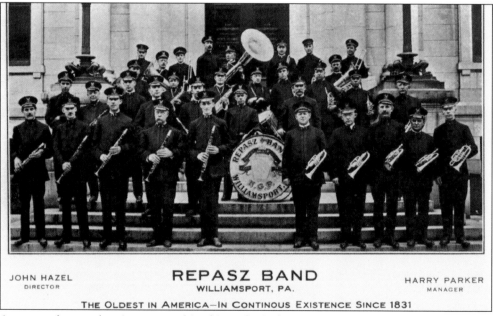

JOHN HAZEL
DIRECTOR

REPASZ BAND
WILLIAMSPORT, PA.

HARRY PARKER
MANAGER

THE OLDEST IN AMERICA—IN CONTINOUS EXISTENCE SINCE 1831

As true today as when it was stated in this early-20th-century postcard, the Repasz Band of Williamsport is still the oldest band in continuous existence in America since 1831. The band played in the presidential inaugural parades for Theodore Roosevelt (1905) and William Howard Taft (1909). (Ackerman Estate collection.)

Fisk, Krimm and Company (Lyman Fisk, Charles Krimm, and H. D. Auchenbach), located at 45 East Third Street, was one of the many sheet music publishers in Williamsport. Its Stopper-Fisk Band complimented the business, playing at many local social and political functions. (DiBartolomeo collection.)

D. S. Andrus operated a music store out of his 21 West Third Street building for many years. Andrus lived at 309 Maynard Street just off Millionaires' Row. His home and music store building remains standing today. (DiBartolomeo collection.)

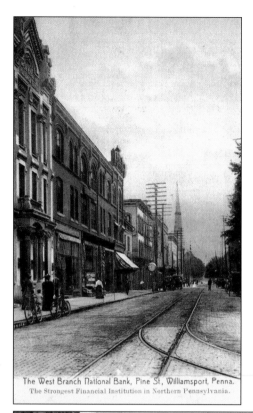

The West Branch National Bank, Pine St., Williamsport, Penna.
The Strongest Financial Institution in Northern Pennsylvania.

Founded as the West Branch Bank and organized in 1835, this was the site of Williamsport's first banking house. In 1865, the bank became the West Branch National Bank. Later, it was known as Northern Central Bank before being absorbed within the mega-sized, national M&T Bank. (Carson collection.)

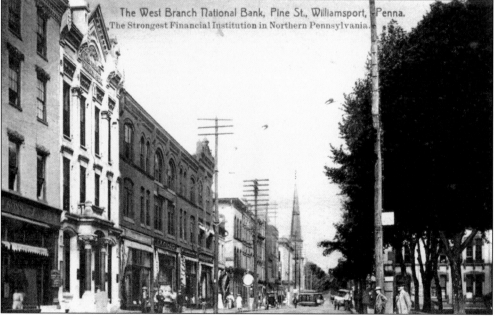

The West Branch National Bank, Pine St., Williamsport, Penna.
The Strongest Financial Institution in Northern Pennsylvania.

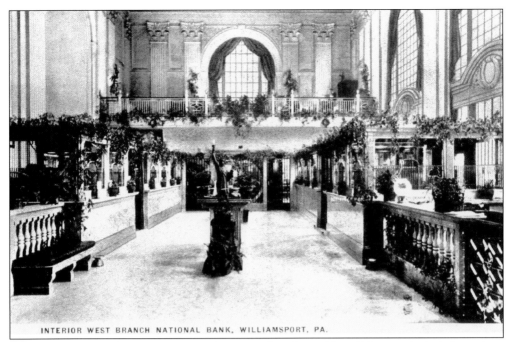

INTERIOR WEST BRANCH NATIONAL BANK, WILLIAMSPORT, PA.

In 1906, Allen P. Perley was West Branch National Bank president. Directors included members of Williamsport's notables: Ezra Canfield, William Emery, John L. Hall, T. S. Clark, Addison Candor, and Allen P. Perley. (DiBartolomeo collection.)

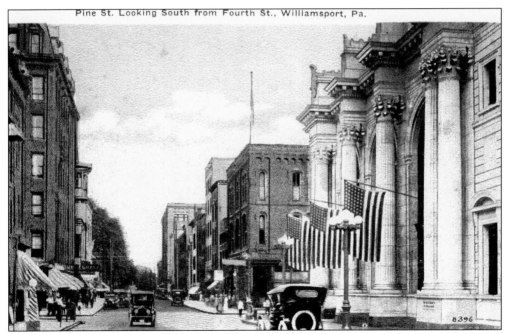

Pine St. Looking South from Fourth St., Williamsport, Pa.

Leaving its home at 209 Pine Street, the West Branch National Bank moved to Pine and West Fourth Streets in 1917, at the site of the former Hess Block. The magnificent glass-domed, fluted-columned, white-marbled edifice was patterned after an Atlanta, Georgia, bank building. (T. S. Meckley collection.)

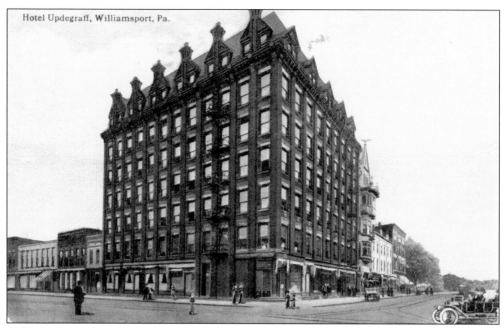

Hotel Updegraff, Williamsport, Pa.

Still a downtown centerpiece today, the Hotel Updegraff building is shown at the corner of Pine and West Fourth Streets. Daniel Updegraff was the builder and original proprietor. This was the site of the Doebler family's Hepburn Inn, which Updegraff had demolished when it ceased operation there. (Stetts-Maietta collection.)

Two young gentlemen of bygone days send greetings from Williamsport to their loved ones at home while working here. (DiBartolomeo collection.)

108

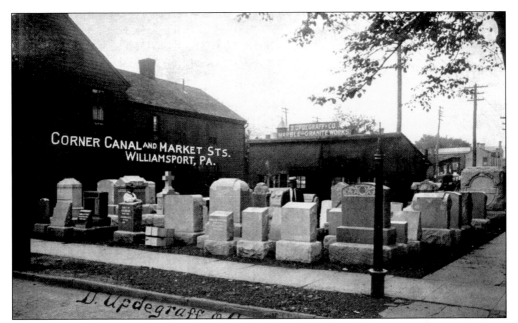

This is a very unusual and sought-after postcard of Daniel Updegraff's grave monument business in downtown Williamsport. (Stetts-Maietta collection.)

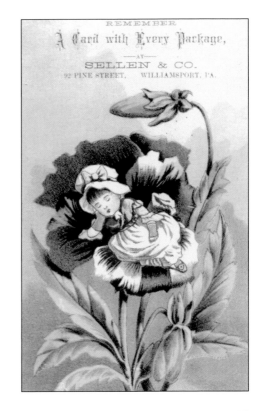

Here is a *c.* 1880 trade card of Williamsport's Sellen and Company, which was owned and operated by Edson Sellen. He lived at the nearby Hepburn House. Promoting the fancy goods sold there, these cards are easily found today and quite popular with postcard collectors. (T. S. Meckley collection.)

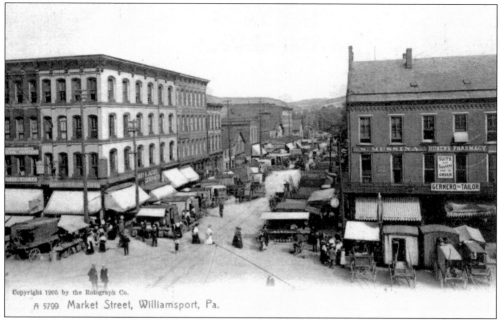

Copyright 1905 by the Rotograph Co.
A 5799 Market Street, Williamsport, Pa.

Two bustling Market Days are shown here as vendors spill out northward from the square along Market Street. (Above, Stetts-Maietta collection; below, Reuel Hartman collection.)

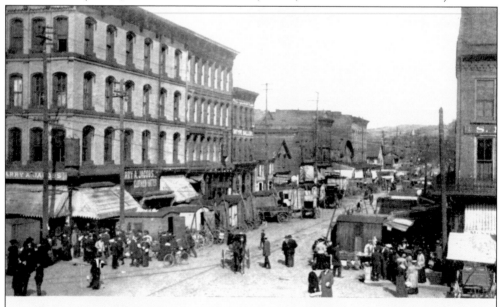

Market Street, Looking North on a Market Day, Williamsport, Pa.

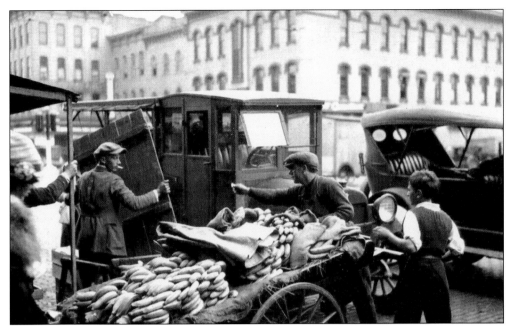

Here is a more modern view of Market Day, still being held in Market Square. Note the change from horse-drawn wagon to an early-style automobile wagon as the vendor removes rear partitions to open shop. (Stetts–Maietta collection.)

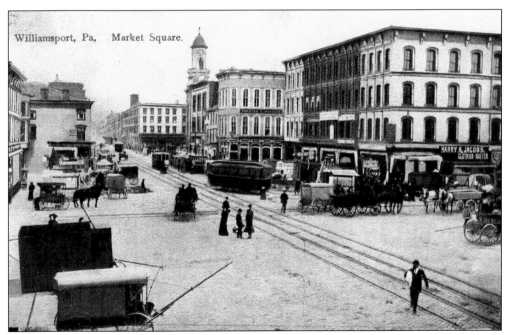

Captured in time is a Victorian-era setting of Williamsport's Market Square, with its many Italianate commercial buildings. Vendor wagons are seen preparing for the market. (T. S. Meckley collection.)

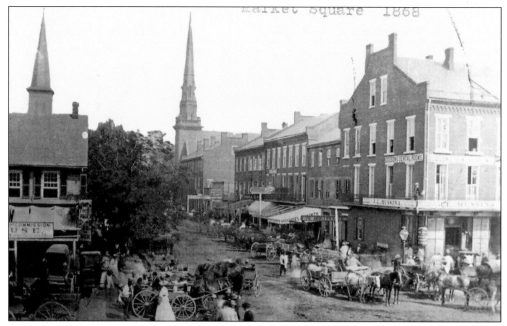

Market Square is shown on Market Day in 1868. Note the lofty spire of the Second Presbyterian Church soaring above the downtown skyline filled with Federal-style brick buildings. (Ackerman Estate collection.)

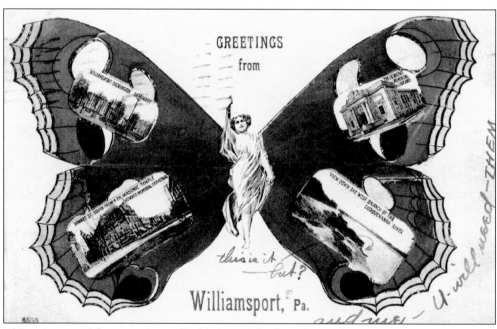

This unique card features a butterflied lady with brilliant hues of red and deep lavender on her wings. The insets show views of Williamsport Dickinson Seminary (now Lycoming College), the James V. Brown Library, the Susquehanna River, the Masonic Temple, and Howard Memorial Cathedral. (DiBartolomeo collection.)

Seven

MASONIC CONCLAVE
CELEBRATIONS

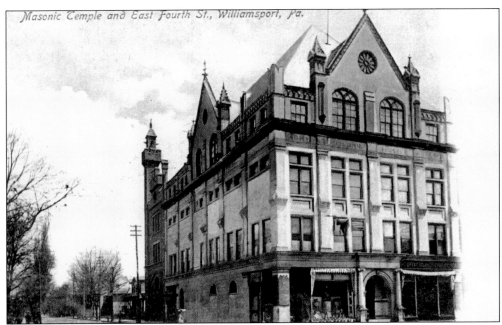

Williamsport's finest are among the ranks of the local Mason members, who not only directed the Masons' growth and well-being but also the city of Williamsport itself. The Blue Lodge No. 106 began its charter in 1806, the same year Williamsport was founded. At the site of the former Second Presbyterian Church, which burned in 1897, the Masonic Temple Association built their first permanent home. It opened on September 5, 1898. The temple is of the French Gothic style and constructed of Indiana limestone. (DiBartolomeo collection.)

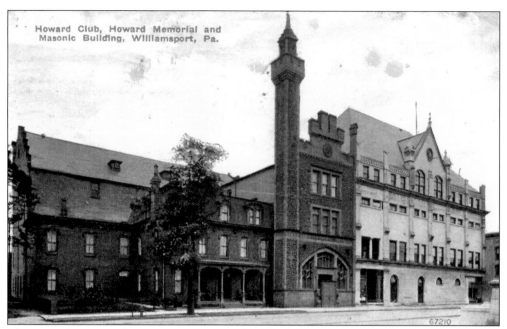

The Scottish Rite Cathedral—designed in the Scotch Baronial style—was a gift in 1902 from the late William Howard. Howard bought and gave the former Piper residence (middle left) as well to the Knights Templar of Williamsport. He envisioned this to be a fitting home for the Temple Club, which was organized on November 19, 1890, by more prominent Knights of Williamsport members like Howard. The Temple Club renamed themselves the Howard Club to show their gratitude for his generosity. Masonic brother Truman P. Reitmeyer was the architect, and Masonic brother William H. C. Huffman was the builder. (Reuel Hartman collection.)

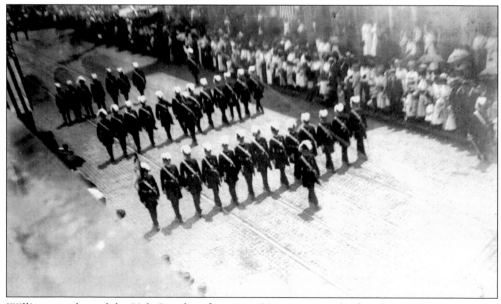

Williamsport hosted the 58th Conclave from May 22 to 24, 1911, the fourth time that the city was honored to hold a Grand Commandery of Pennsylvania event. (Ackerman Estate collection.)

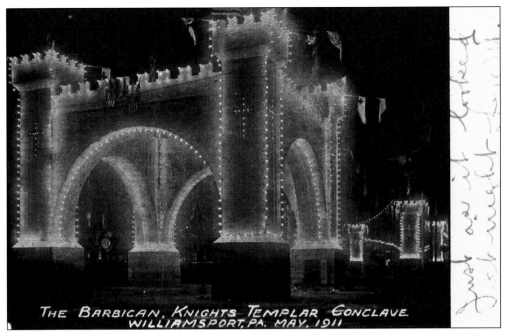

The Williamsport Consistory hosted a reception at their facilities for visiting Knights and their ladies on the evening of Tuesday, May 23, 1911. The Stopper and Fisk Orchestra performed for the dancing festivities in the Cathedral Banquet Room. (Sprunger collection.)

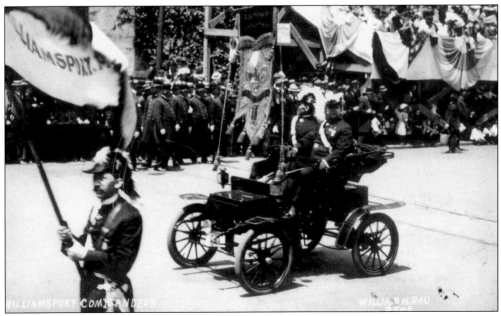

John F. Laedlein of Williamsport served as grand commander of the annual conclave. There were approximately 17,500 members of the local masonry at that time. (DiBartolomeo collection.)

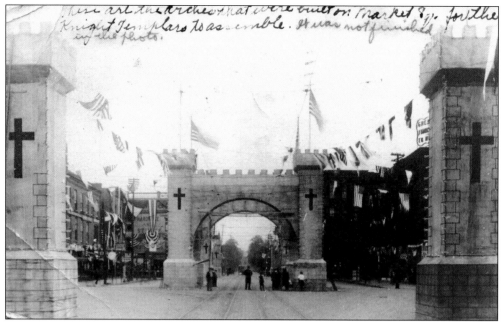

Here are the arches that were built on Market Sq. for the Knight Templars to assemble. It was not finished in the photo.

Seven thousand parade participants went through these ceremonial arches as part of the annual parade and review on Tuesday, May 23, 1911. At 9:45 a.m. a first cannon shot marked the call for formation while a second shot at 10:00 a.m. signaled for the head of the column to begin marching. On the back of this postcard, the writer tells his uncle in Blair County, Pennsylvania, that "it took 1HR for the parade to pass one point. All these arches were lit with electric lights. Made for a beautiful sight." (Taber Museum collection.)

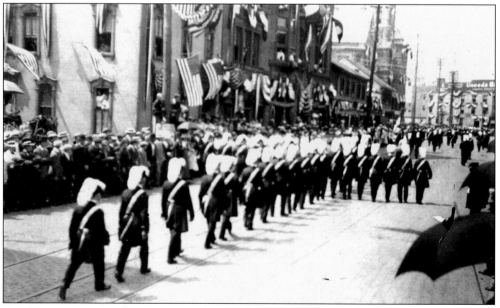

The Flower of the Manhood of Pennsylvania, shown here, marched in all their Masonic finery in 1911 during the 58th Annual Conclave of the Grand Commandery of the Knights Templar of Pennsylvania. (Stetts-Maietta collection.)

116

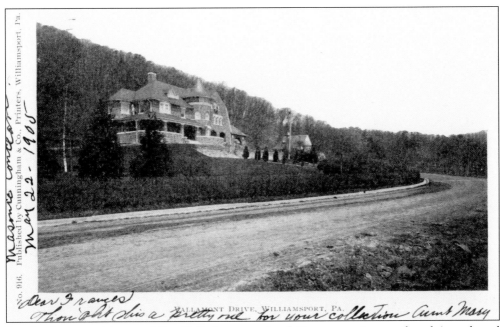

No. 916. Published by Cunningham & Co., Printers, Williamsport, Pa.

Masonic Conclave
May 22 - 1905

Dear Frances
Thought this a pretty one for your collection Aunt Mary

BALLAMONT DRIVE, WILLIAMSPORT, PA.

Lumber baron and lawyer Allen P. Perley was a local Mason, serving on the advisory board for the 58th Annual Conclave in 1911. The last time that the local Masons had entertained the Pennsylvania Knights had been at the 52nd Conclave in 1905. Williamsport gained a reputation as "the city that does things" due to their tremendous hospitality. (T. S. Meckley collection.)

Masons are shown in formation along South Market Street, near the review stand on West Third Street in front of the courthouse, where each column would be reviewed by the right eminent grand commander and the officers and past officers of the commandery. (Stetts–Maietta collection.)

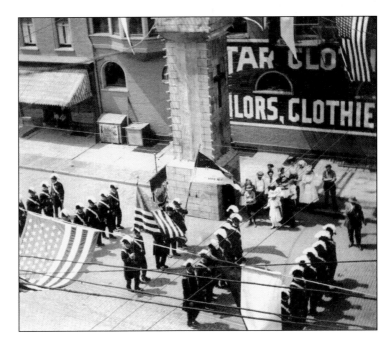

Constructed in 1910, the Acacia Club building was a gift of 33-degree Masonic brothers Timothy S. Clark, John L. Hall, and David A. Howe. The Grecian-style edifice was designed to hold general club activities on the first two floors, an armorial hall on the third, and an extension of the Howard Memorial Cathedral Banquet Hall on the fourth. Today, the first floor hosts dining for lunches and special events for the public. (T. S. Meckley collection.)

Eight

WILLIAMSPORT'S CENTENNIAL CELEBRATION

Susquehanna River Dam and Williamsport Sky Line.

The mighty Susquehanna River roars across the Hepburn Street Dam, with the skyline of the then newly beginning industrial age at the onset of Williamsport's post-lumber era. In 1906, Williamsport celebrated the centennial of its founding by Michael Ross. It is believed that Ross named the new town after his son, William. (T. S. Meckley collection.)

Compliments of

The Bush & Bull Co.

1850. West Third Street, Looking East from Pine.

WILLIAMSPORT CENTENNIAL
1806-1906

July 3d and 4th.

The Bush and Bull dry goods store, at 43-47 West Third Street, was Williamsport's other leading department store, located catty-corner to rival competitor L. L. Stearns and Sons. Bush and Bull opened here in 1884 and was one of four dry goods stores operated by Solomon Bush and James Bull. It closed in August 1936, after it had been sold to an out-of-town owner from Brooklyn, New York, just two years earlier. (Ackerman Estate collection.)

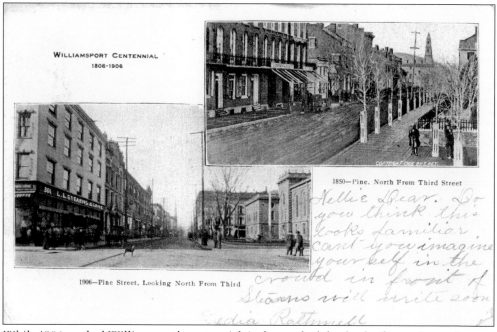

WILLIAMSPORT CENTENNIAL
1806-1906

1850—Pine, North From Third Street

1906—Pine Street, Looking North From Third

While 1906 marked Williamsport's centennial, it also marked the death of Laten Legge Stearns. Downtown stores closed for one hour to pay tribute to and honor the passing of the legendary merchant. (Stetts-Maietta collection.)

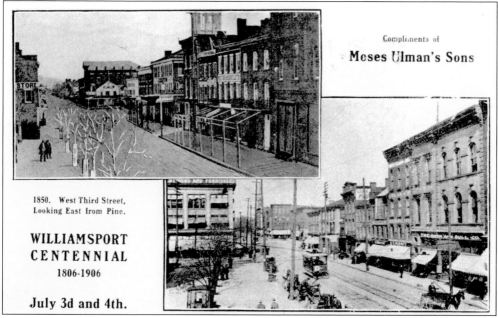

Founded in Liberty, Pennsylvania as a general merchandise store, Moses Ulman and Sons was established in 1856, when Moses Ulman moved to Williamsport. He opened his store on the block shown, and his sons Hiram and Lemuel helped him run the business. Lemuel became president upon the death of his father in 1912. (Ackerman Estate collection.)

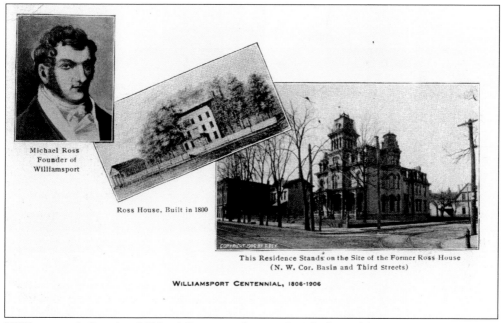

Williamsport's founder, Michael Ross, was honored with this celebratory centennial card, showing the dashing Ross and his stately brick home. The house was later replaced by James V. Brown's massive mansard-roof mansion (right). (Stetts-Maietta collection.)

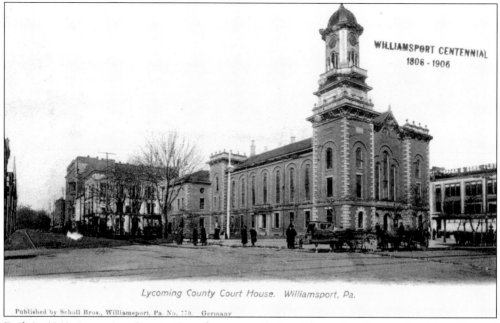

WILLIAMSPORT CENTENNIAL
1806 - 1906

Lycoming County Court House. Williamsport, Pa.

Published by Scholl Bros., Williamsport, Pa. No. 770. Germany

Built in 1860, Lycoming County Courthouse was designed by nationally noted architect Samuel Sloan, who designed a similar structure for the city of Lock Haven. Unfortunately, after 109 years, the mighty Italianate edifice was demolished. Its tower clock survives atop the local Neece Paper Company store thanks to owner Fred Neece's forethought and vision. (Taber Museum collection.)

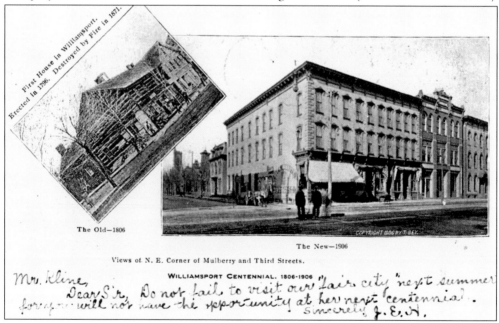

First House in Williamsport. Erected in 1796. Destroyed by Fire in 1871.

The Old—1806

The New—1906

Views of N. E. Corner of Mulberry and Third Streets.

WILLIAMSPORT CENTENNIAL. 1806-1906

Mr. Kline,
Dear S'r, Do not fail to visit our "fair city" next summer for you will not have the opportunity at her next "centennial".
Sincerely J. E. H.

One of a series of historically based centennial postcards was sent by writer J. E. H. to Prof. Benjamin Kline of North Wales, Pennsylvania, in March 1906, inviting him to partake in the festivities of the upcoming events planned for July in the "fair city" of Williamsport. The "new" site shown is a parking lot today, with its neighbor surviving, now home to law offices after years as the Page Funeral Home. (Private collection.)

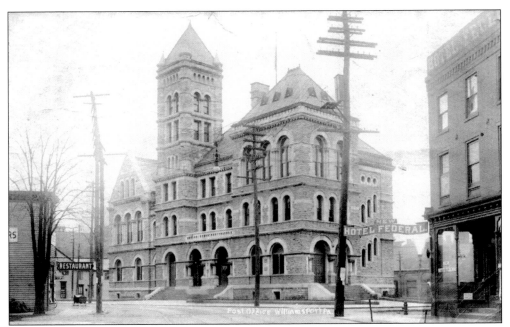

This rare real picture postcard shows the federal post office building, which opened to the public on Sunday, June 28, 1891. It is flanked by the Hotel Federal (right) and the *c.* 1897 cigar shop of William H. Lundy (left). (DiBartolomeo collection.)

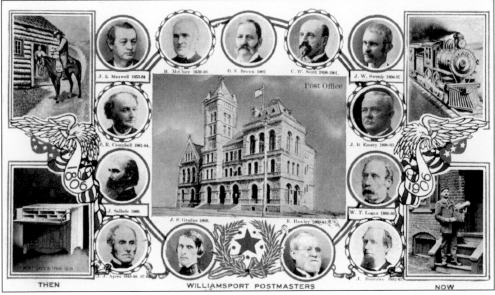

This centennial card marks the postal history and postmasters of Williamsport from 1799 until 1906. The card shows the new federal post office, which was dedicated in June 1891. Prior to this, postmasters had the privilege of choosing the post office location. Most often, the post office was located at the Ayres and Lundy Building (22 East Third Street), where Ayres and his son-in-law and partner J. J. Lundy had their insurance and book shop businesses—even when Ayres no longer served as postmaster. (Ackerman Estate collection.)

Postmaster James Sweely lived at this Eber Culver–designed Victorian brick mansion at 777 West Third Street, which was being built by John H. Price Jr., secretary and treasurer of the Williamsport Land and Lumber Company at the time. (T. S. Meckley collection.)

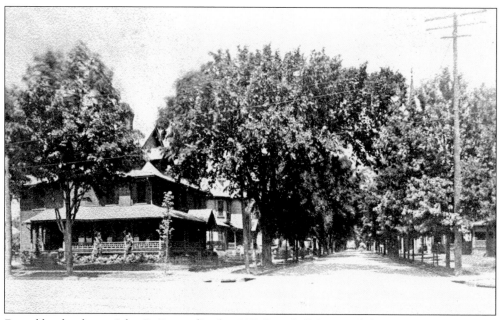

Famed lumber baron John B. Emery lived at 305 Campbell Street while serving as postmaster. The Eber Culver–designed Queen Anne masterpiece Victorian was owned by the Emery family until the late 1960s. Unfortunately, some of its exterior details have been removed in recent years, but the building still shines with the remaining original details of patterned inlay brick, ornate chimneys and stained glass. (T. S. Meckley collection.)

In 1906, J. B. Emery built 820 West Third Street (center) as a wedding present for his daughter and new son-in-law, Julia and John H. Foresman. The Colonial Revival–style brick mansion was owned by the Foresman family until 1968 and has been owned by the author since 1992. The Foresmans' daughter, the late Dr. Sally Foresman Hoyt Spofford, provided invaluable assistance during the restoration of her family homestead. (T. S. Meckley collection.)

Legendary lumber baron Seth T. Foresman was the 16th mayor of Williamsport, serving as such during the city's centennial celebration. The Seth T. Foresman family lived at his enormous Victorian mansion, 1314 West Fourth Street, which still stands today at the end of Williamsport's Millionaires' Row proper. In 1906, the Foresmans resided at 835 West Fourth Street. (Stetts-Maietta collection.)

Note that the sender of this centennial card added, "Our wisemen." Justly so in all regards, lumber baron Seth T. Foresman is placed as mayor at the pinnacle of the then city hall building. The old city hall building is individually listed on the National Register of Historic Places, being rescued by local entrepreneur Richard H. Lundy Jr. (DiBartolomeo collection.)

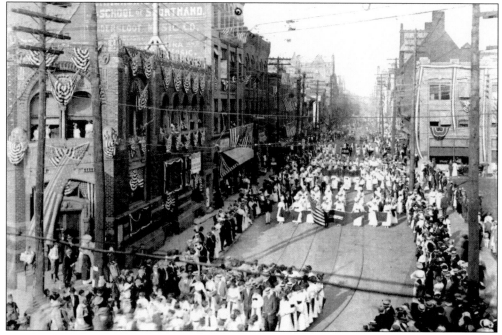

Thousands of patriotic Williamsporters flock to the streets to celebrate the town's centennial, as shown along downtown West Fourth Street in this amazing real picture postcard. (Stetts-Maietta collection.)